PRINT'S BEST T-SHIRT PROMOTIONS 2

Library of Congress
Catalog Card Number 92-081124
ISBN 0-915734-95-8

RC PUBLICATIONS

President and Publisher: Howard Cadel
Vice President and Editor: Martin Fox
Creative Director: Andrew Kner
Managing Director, Book Projects: Linda Silver
Administrative Assistant: Nancy Silver
Assistant Art Director: Michele L. Trombley

Print's Best
T-SHIRT PROMOTIONS 2
WINNING DESIGNS FROM PRINT MAGAZINE'S NATIONAL COMPETITION

Edited by
LINDA SILVER

Introduction by
PAMELA IVINSKI

Designed by
ANDREW KNER

Published by
**RC PUBLICATIONS, INC.
NEW YORK, NY**

Take a look around you at a baseball game played on a blue-sky day of summer. Are the fans decked out in home team colors? Some of them. But for the most part, you'll be surrounded by a sea of white. Everybody's wearing a T-shirt, the great American uniform.

In fact, the T-shirt originated as a component of the military uniform, issued by the United States Navy during World War II. The basic elements of the shirt itself have remained remarkably consistent: white cotton, boxy shape, crew neck. Color, sleeve length, and trim sometimes vary, but the classic white short-sleeved T-shirt endures.

Long before Madonna made a fashion issue out of underwear as outerwear, James Dean subverted the T-shirt as undershirt, turning its blank surface into an emblem of the '50s Rebel Without a Cause. With the advent of mass-production printing methods in the '60s, protest movements, and the explosion of rock 'n' roll, the decorated T-shirt became standard wear for young Americans, rebels with and without causes. In the '70s, the T-shirt served both the rock 'n' roll equivalent of the corporation, the "supergroup" (remember the Rolling Stones tongue logo?) and its antithesis, punk rock (c.f. the Sex Pistols and their collage-style desecration of the Queen). The T-shirt, the uniform of a culture, allows for a great degree of personal expression.

"This is a T-SHIRT" proclaims a premium designed by Thompson & Company of Memphis, and found in this edition of *PRINT's Best T-Shirt Promotions*. "A temporary tattoo. A cotton canvas. A perambulating poster," it continues. "A wearable statement and a wardrobe staple." Clothing has long featured design and pattern. The T-shirt brought print to the language of clothing, sometimes as caption for an image, sometimes as a message on its own.

The white T-shirt's snowy purity presents a charged field to the designer working for an account. The T-shirt embodies a tension between conformity and rebellion, corporate promotion and anarchist defiance. For example, the Adidas logo, resurrected in the current '70s revival, was quickly mutated into a cannabis leaf by some arbiters of underground fashion. The identity program including a T-shirt benefits from this combination of acceptability and outlaw style. Perhaps Kurt Cobain, of the "grunge" band Nirvana (who committed suicide in 1994), summed it up best when he appeared at a Rolling Stone cover shoot in a self-penned T-shirt reading "Corporate magazines still suck."

CONTENTS

Consider the use of the bull's-eye target on a number of T-shirts. The classic British rock band The Who sported shirts bearing a target, plain and simple, to signal their Mod, Pop Art-inflected style. In an example in this volume, Peterson & Company, designing for designers, employed the symbol to poke morbid fun at their peers and the city of Miami, host to a 1993 AIGA conference. "AiGA MiAMi TOURIST" reads the shirt front, with a target placed squarely on the back, in reference to tourist shootings in that city. Most recently, the symbol supports a serious cause as the icon for "Fashion Targets Breast Cancer." These T-shirts are displayed on the bodies of supermodels, rock stars for the '90s.

The association of the T-shirt and health has a long history, arising from the shirt's suitability to athletic endeavor. The tradition of the souvenir T-shirt to commemorate the running of road races is still strong, judging from the examples reproduced in this edition of *PRINT's Best*. Developed in part to create community in a sport characterized by "the loneliness of the long-distance runner," the marathon T-shirt continues to represent the ultimate statement of "been there, done that."

The T-shirt has also become a staple of the sports fan's wardrobe, and nowhere is this more evident than in the popularity of National Basketball Association-related paraphernalia. Not just in images of the great players like Michael Jordan, seen in shirts by Nike in this volume, but also in Reebok's venture into "trash talk," in an all-text T-shirt by The Mednick Group, Culver City, which boasts "360 dunk in your face, you can't compete..." It concludes, somewhat ironically, "No words, just deeds, no limits, baby." The success of NBA basketball in the '90s has as much to do with selling style as it does with the action on the court.

The same goes for latest fad in retailing: the coffee bar (a trend, like grunge rock, courtesy of Seattle). Your graphics have to be as good as your Hawaiian Kona roast. If the home cappuccino maker was a symbol of the Yuppie '80s, Starbucks coffee mug designs may be icons of the '90s. This edition of *PRINT's Best T-Shirt Promotions* highlights designs gathered from the 1993-94 PRINT's Regional Design Annuals. A new feature is the addition of information on budget, quantity, and printing process (when provided by the designers), and promotional purpose. Like the printed page, the T-shirt is both ephemeral and enduring. We hope you'll be inspired by this record of our time.—*Pamela Ivinski*

DESIGN FIRM:

John Evans Design,

Dallas, Texas

ART DIRECTOR/

DESIGNER/ILLUSTRATOR:

John Evans

PURPOSE: Retail sale

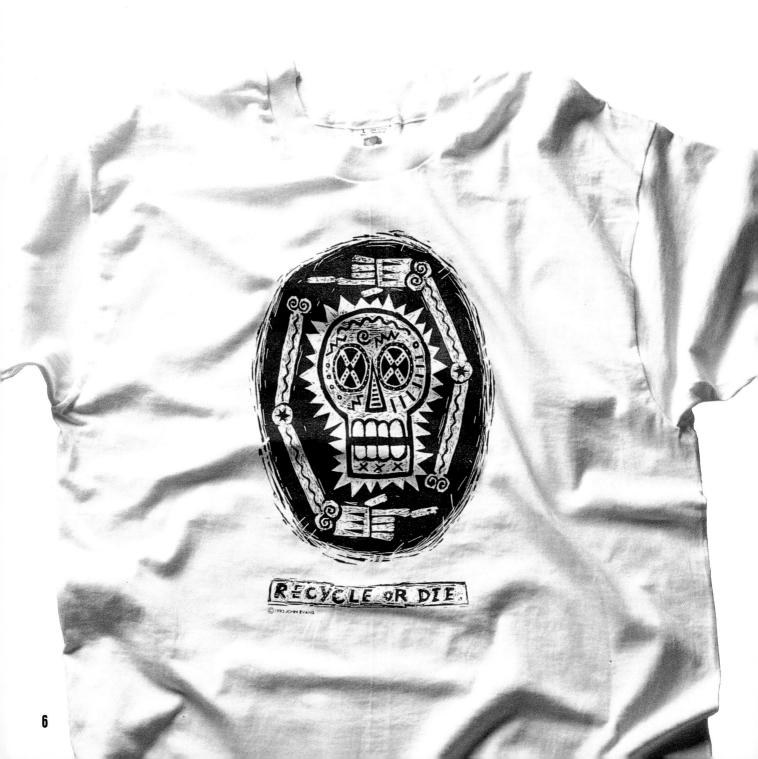

DESIGN FIRM:

Hess Design, South Natick,

Massachusetts

ART DIRECTOR:

Pam Gibson

DESIGNER/ILLUSTRATOR:

Karyn Goba

QUANTITY: 5000

PRINTING PROCESS:

Silkscreen

PURPOSE: Tradeshow

give-away

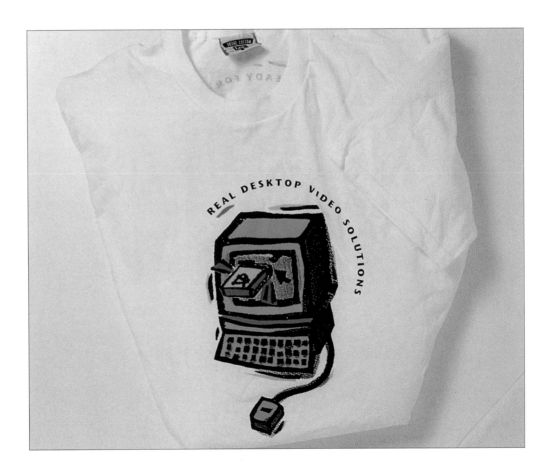

Avid Technology

DESIGN FIRM:

John Evans Design,

Dallas, Texas

ART DIRECTOR/

DESIGNER/ ILLUSTRATOR:

John Evans

PURPOSE: Retail sale

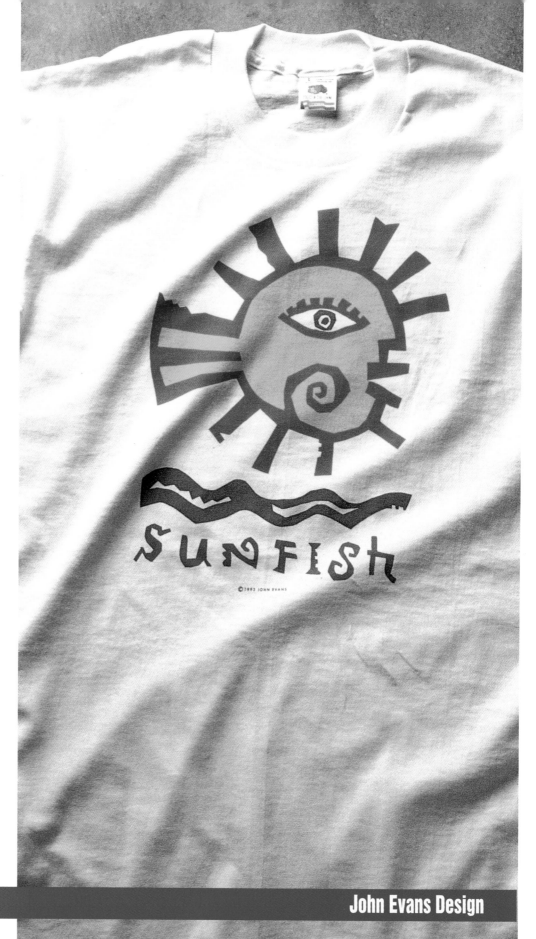

John Evans Design

8

Designer and printer of
high-quality art T-shirts
sold wholesale through a
catalog.
DESIGN FIRM:
Standard Deluxe, Inc.,
Waverly, Alabama
DESIGNER: Scott Peek
PRINTING PROCESS:
Silkscreen on dyed shirt

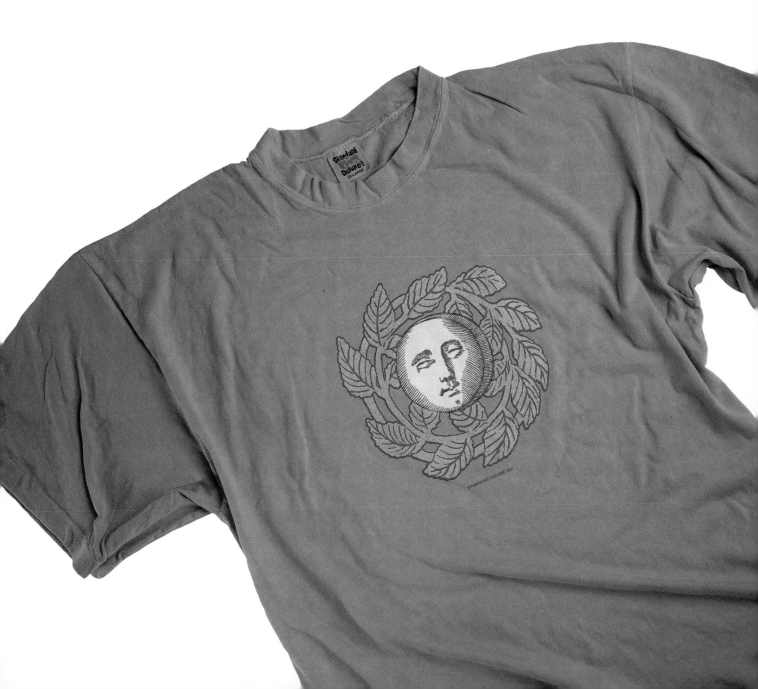

DESIGN FIRM:

California Tan,

Los Angeles, California

ART DIRECTOR:

Carin Swartz

DESIGNERS:

Carin Swartz, Julie Evidon

PRINTER:

Coastal Printworks, Inc.

PURPOSE: Promotional

Below, left: Intensifier Lotion packaging; right: promotional package for Intensifier Lotion; bottom: additional T-shirt designs.

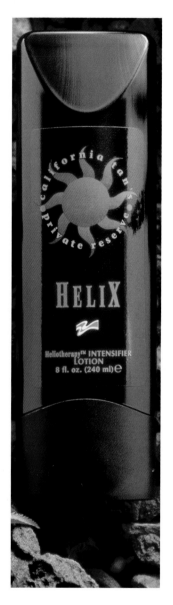

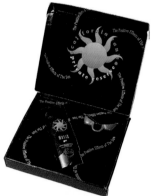

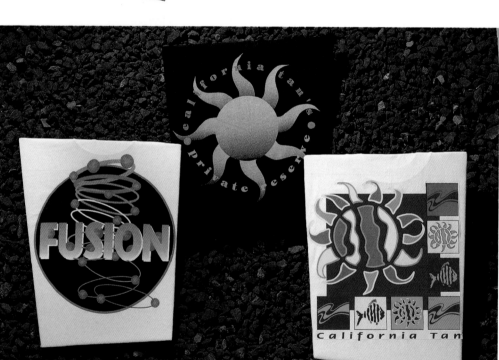

California Tan (Suncare Products)

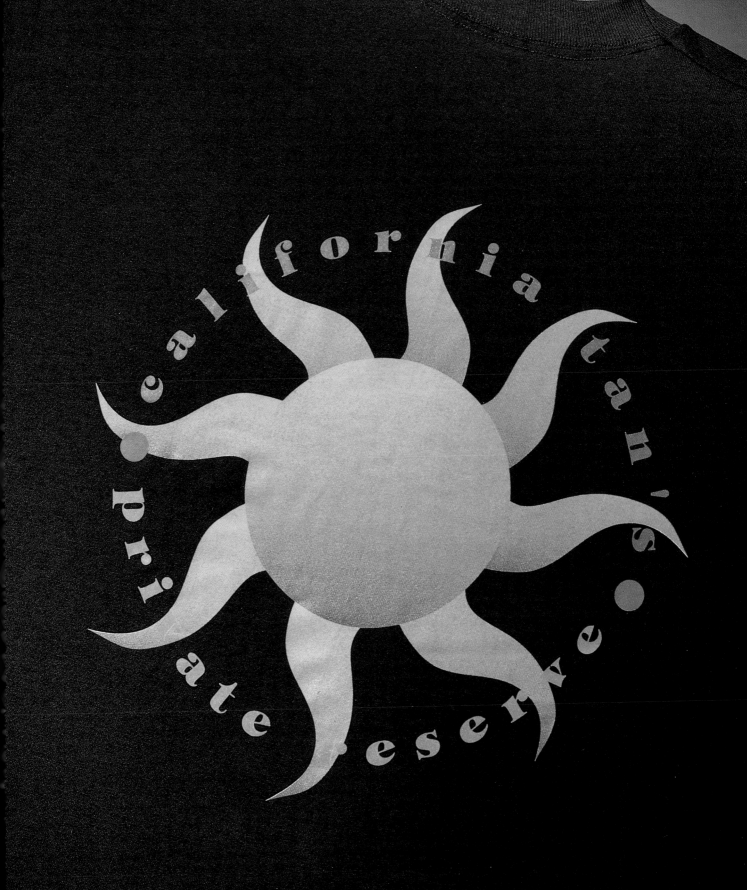

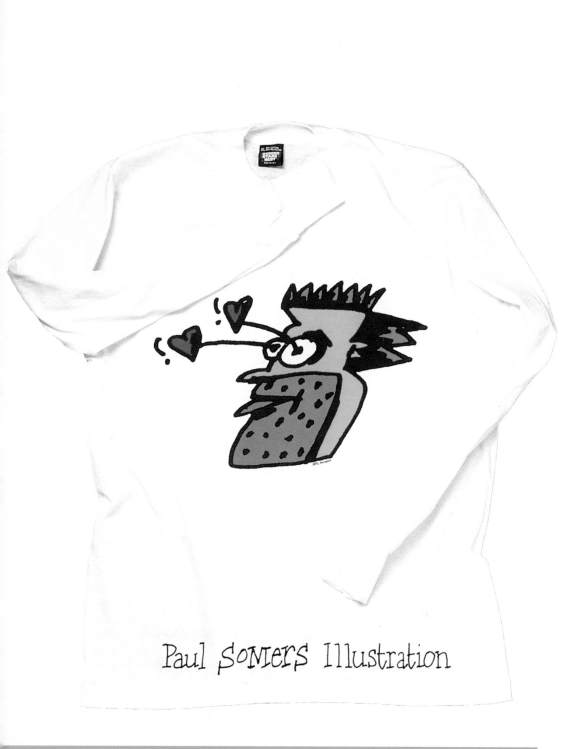

Paul Somers Illustration

DESIGN FIRM:

Somers Design,

Chicago, Illinois

ART DIRECTOR: Les Kidd

DESIGNER/ILLUSTRATOR:

Paul Somers

PRINTING:

Kidd International

BUDGET: $1200

QUANTITY: 150

PRINTING PROCESS:

Silkscreen

PURPOSE:

Self- promotion

Paul Somers Illustration

DESIGN FIRM:

Plateau Graphic

Design Group,

Renton, Washington

ART DIRECTOR/

DESIGNER/ILLUSTRATOR:

Robert Mercer

PRINTING PROCESS:

Silkscreen

PURPOSE: Part of effort

to promote a coffee blend

through novelty items

such as T-shirts, stickers,

and coffee cups.

Starbucks Coffee Co.

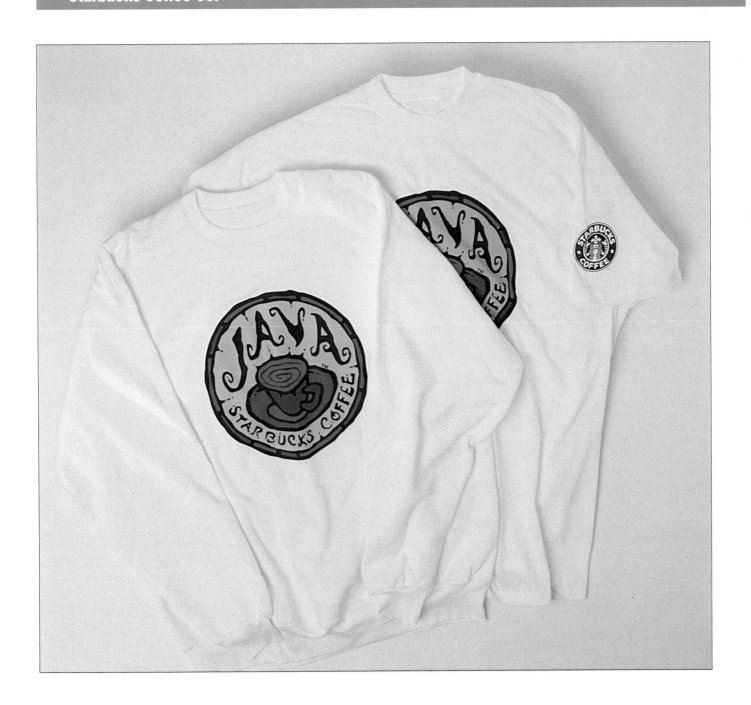

DESIGN FIRM:
Tom Hair Marketing
Design, Houston, Texas
ART DIRECTOR: Tom Hair
DESIGNERS: Don Crum,
Bea Garcia
QUANTITY: 500+
PRINTING PROCESS:
Silkscreen from disk
PURPOSE: Gift for all
marathoners to wear
while training; also used
to promote the next
year's race.

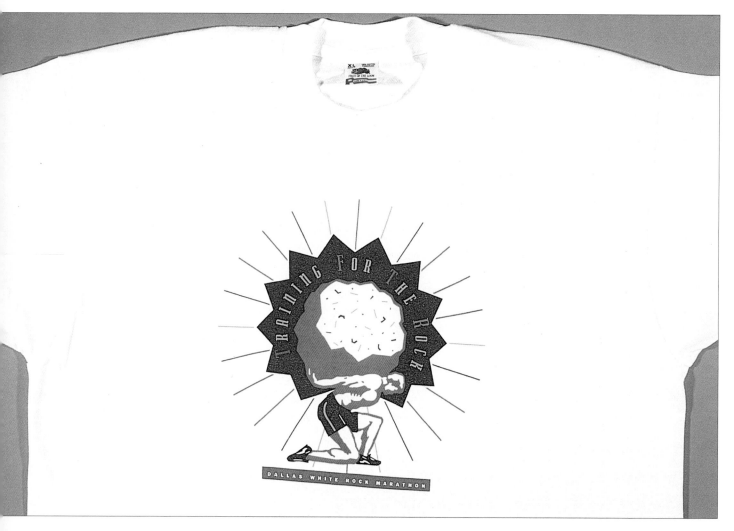

Dallas White Rock Marathon (City Marathon)

DESIGN FIRM:
Tom Hair Marketing
Design/Savage Design
Group, Inc., Houston,
Texas
ART DIRECTOR: Tom Hair
DESIGNERS: Bea Garcia,
Paul Jerde
PHOTOGRAPHER:
Pete Lacker
QUANTITY: 1500
PRINTING PROCESS:
Silkscreen from disk
PURPOSE: Gift for all
marathon participants

Below: promotional mailers; bottom: poster.

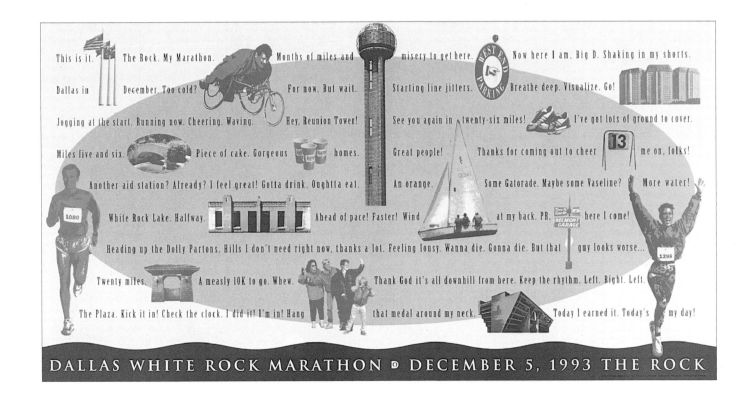

This is it. The Rock. My Marathon. Months of miles and misery to get here. Now here I am, Big D. Shaking in my shorts.

Dallas in December. Too cold? For now. But wait. Starting line jitters. Breathe deep. Visualize. Go!

Jogging at the start. Running now. Cheering. Waving. Hey, Reunion Tower! See you again in twenty-six miles! I've got lots of ground to cover.

Miles five and six. Piece of cake. Gorgeous homes. Great people! Thanks for coming out to cheer me on, folks!

Another aid station? Already? I feel great! Gotta drink. Oughtta eat. An orange. Some Gatorade. Maybe some Vaseline? More water!

White Rock Lake. Halfway. Ahead of pace! Faster! Wind at my back. PR, here I come!

Heading up the Dolly Partons. Hills I don't need right now, thanks a lot. Feeling lousy. Wanna die. Gonna die. But that guy looks worse...

Twenty miles. A measly 10K to go. Whew. Thank God it's all downhill from here. Keep the rhythm. Left. Right. Left.

The Plaza. Kick it in! Check the clock. I did it! I'm in! Hang that medal around my neck. Today I earned it. Today's my day!

DALLAS WHITE ROCK MARATHON ▷ DECEMBER 5, 1993 THE ROCK

15

STAND SLAMMIN'
BUNT OVER
BAMMIN'
THE FENCE
JAMMIN'
POWER HITTER
PLAY OUTTA YOUR
MIND
NOT OUTTA YOUR
LEAGUE
PLANET REEBOK
NO WIMPS NO LIMITS

DESIGN FIRM:

The Mednick Group,

Culver City, California

ART DIRECTORS:

Scott Mednick, Loid Der

DESIGNER: Loid Der

PURPOSE: Retail sale

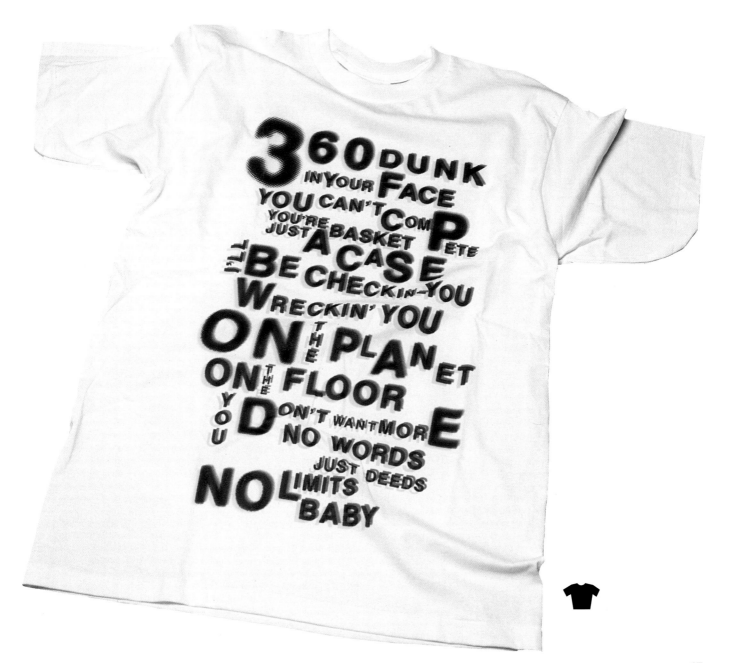

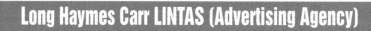

DESIGN FIRM:

Long Haymes Carr LINTAS,

Winston-Salem,

North Carolina

VICE CHAIRMAN/CHIEF

CREATIVE OFFICER:

Robert Graham

CREATIVE DIRECTOR:

David Shapiro

ART DIRECTOR/

DESIGNER: Chris Edwards

BUDGET: $1725

QUANTITY: 200

PURPOSE: For

distribution to agency

employees in recognition

of LINTAS Day 1993.

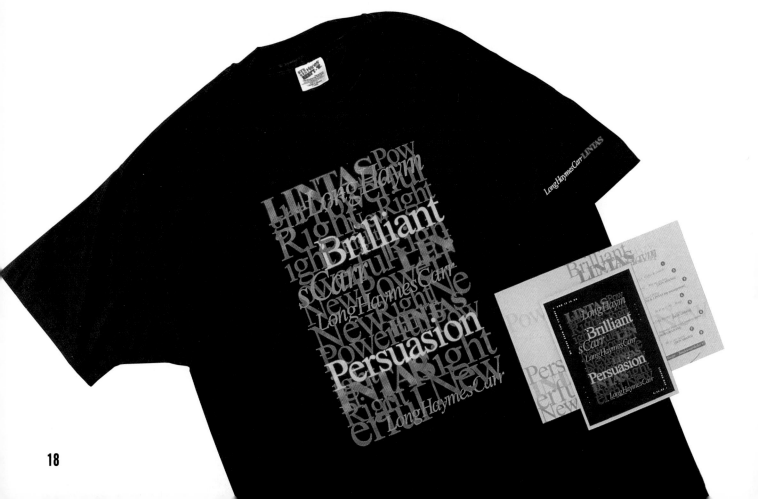

Kansas City Blues and Jazz Festival

DESIGN FIRM: WRK,

Kansas City, Missouri

ART DIRECTOR/

DESIGNER/ILLUSTRATOR:

Ann Willoughby

PURPOSE: Promotional

DESIGN FIRM:

Velva Sheen/Genus

Manufacturing,

Cincinnati, Ohio

CREATIVE DIRECTOR:

Janet Reuter

ART DIRECTOR:

Bob Powers

ILLUSTRATOR:

Tim Newkirk

PRINTING PROCESS:

Front/back belt print

with overprint and

shimmer ink

PURPOSE: Retail sale

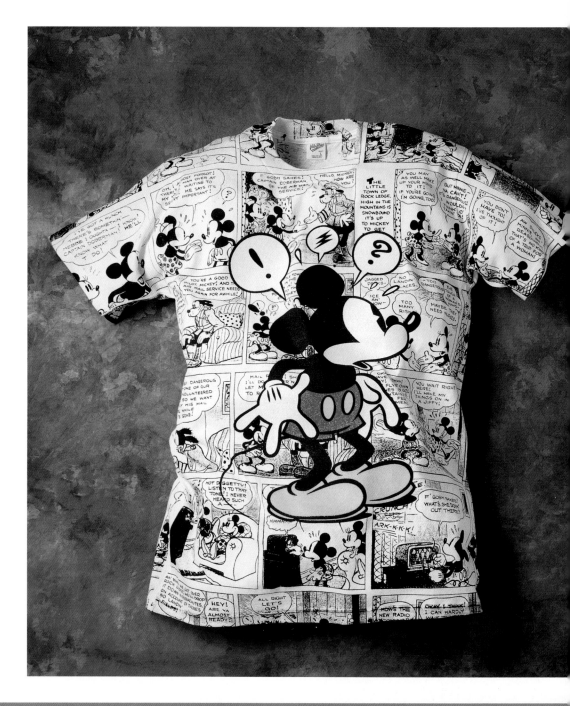

Mickey Unlimited by Velva Sheen/Disney

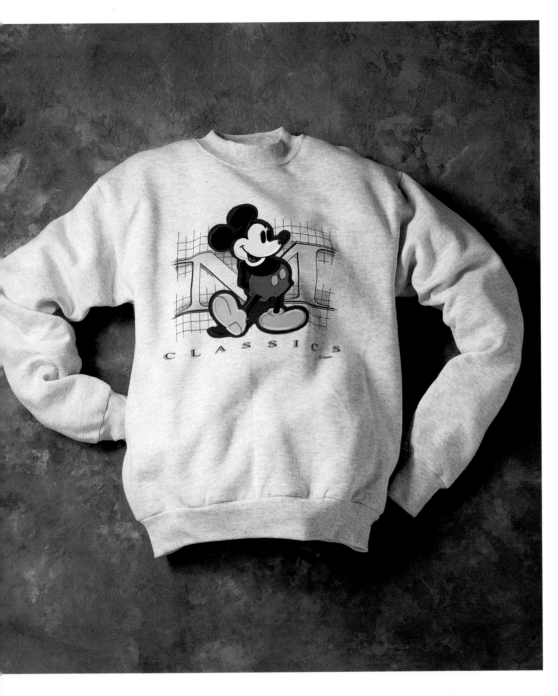

DESIGN FIRM:

Velva Sheen/Genus

Manufacturing,

Cincinnati, Ohio

CREATIVE DIRECTOR:

Janet Reuter

ART DIRECTOR:

Bob Powers

ILLUSTRATOR:

Tim Newkirk

PRINTING PROCESS:

Silkscreen with appliqué

and embroidery

PURPOSE:

Men's department and

specialty store sales

Mickey & Co. by Genus/Disney

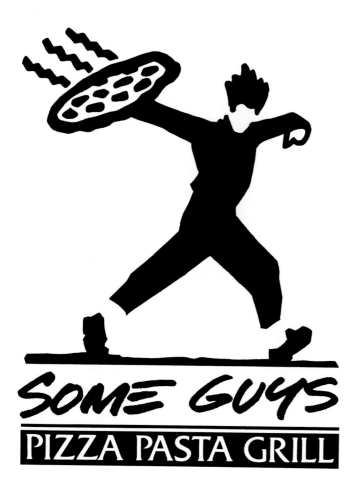

DESIGN FIRM:

Dean Johnson Design,

Indianapolis, Indiana

ART DIRECTOR/

DESIGNER/ILLUSTRATOR:

Bruce Dean

PRINTING PROCESS:

Color transfer

(Canon color copier)

PURPOSE: Retail sale

Magritte-inspired illustrations on T-shirts shown here were part of a series of shirts with masterpiece-inspired illustrations. Top of page: Two symbols in the client's identity campaign.

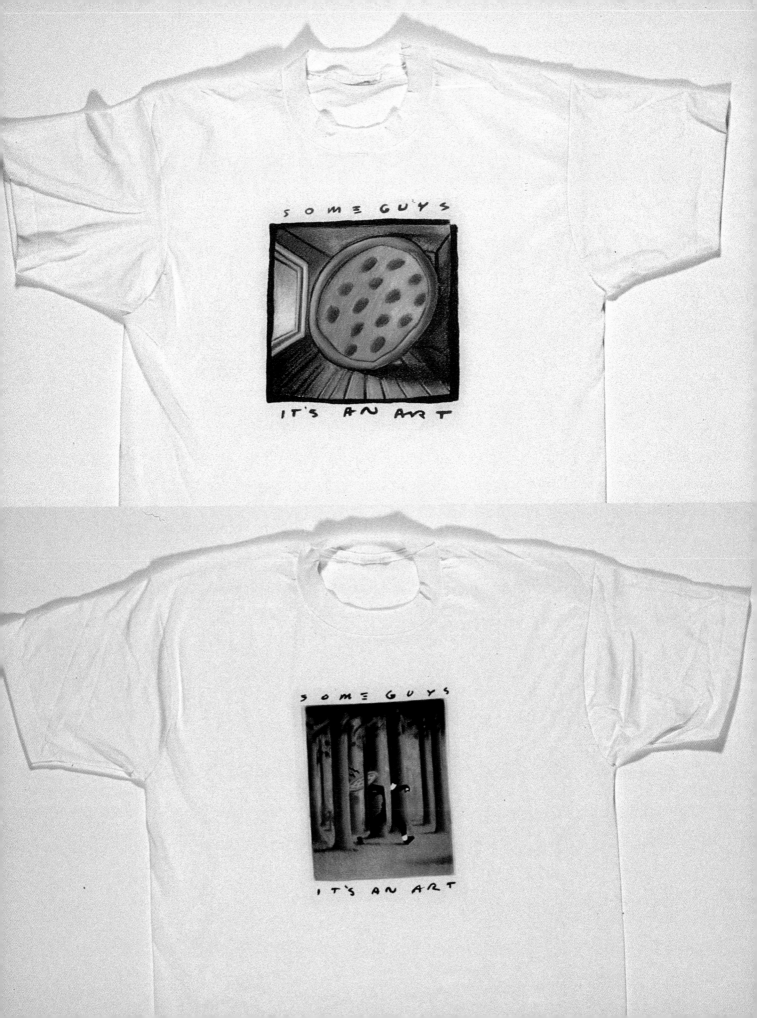

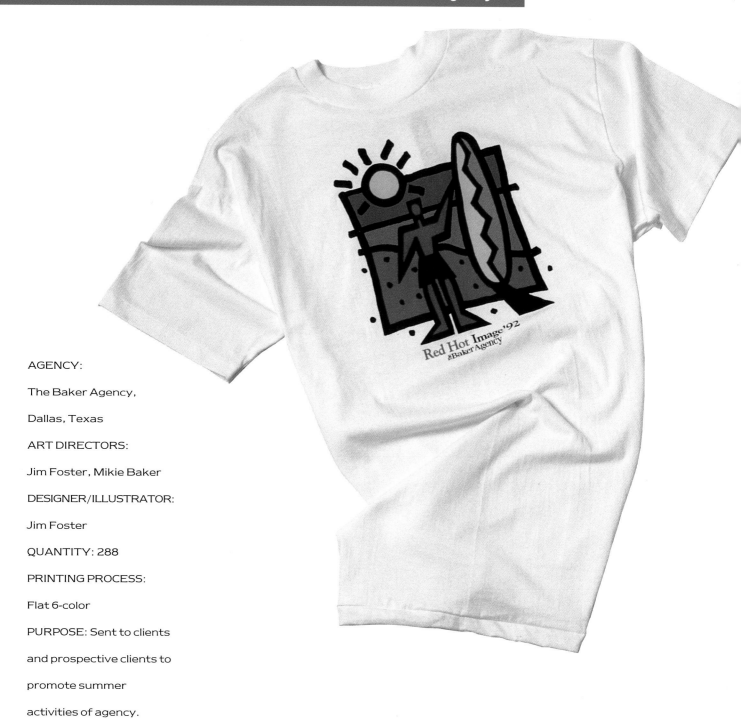

AGENCY:

The Baker Agency,

Dallas, Texas

ART DIRECTORS:

Jim Foster, Mikie Baker

DESIGNER/ILLUSTRATOR:

Jim Foster

QUANTITY: 288

PRINTING PROCESS:

Flat 6-color

PURPOSE: Sent to clients

and prospective clients to

promote summer

activities of agency.

DESIGN FIRM:

Winterland Productions,

San Francisco, California

ART DIRECTOR:

Richard Prahm

DESIGNER:

Christie Rixford

PURPOSE: Women's wear

retail sale

AGENCY:

Mithoff Advertising, Inc.,

El Paso, Texas

ART DIRECTOR/

DESIGNER/ILLUSTRATOR:

Clive Cochran

BUDGET: $12 each,

total $300

QUANTITY: 25

PRINTING PROCESS:

Silkscreen

PURPOSE: Company

bowling-team uniform for

Heart Association bowling-

night fundraiser

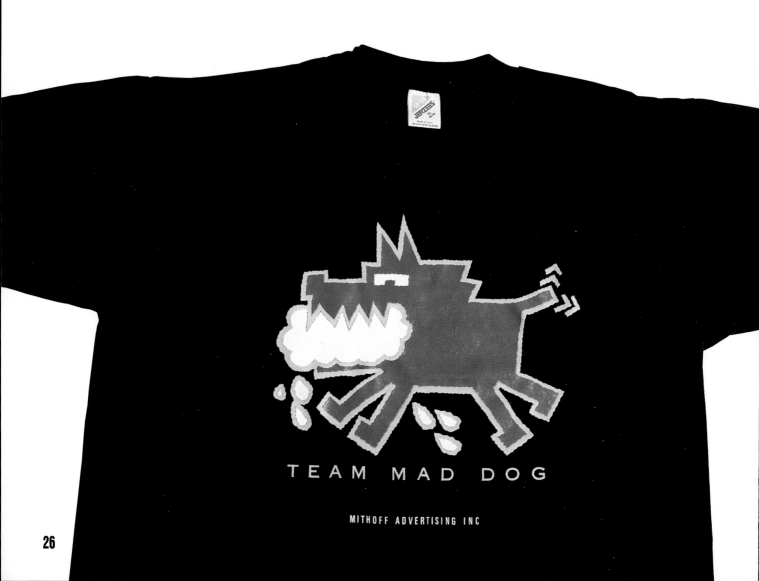

DESIGN FIRM:

Lehner & Whyte, Inc.,

Montclair, New Jersey

ART DIRECTORS/

DESIGNERS:

Donna Lehner, Hugh Whyte

ILLUSTRATOR:

Hugh Whyte

PURPOSE: Retail sale

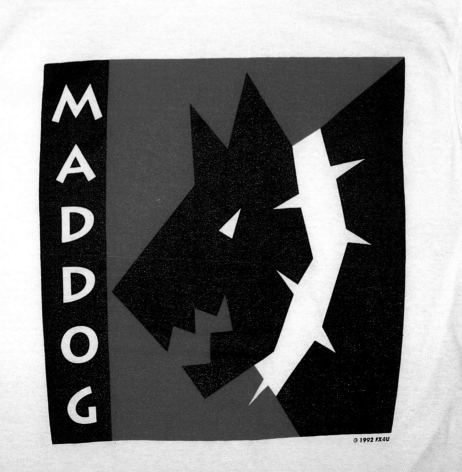

Annual promotional event held at Seattle Center.

DESIGN FIRM:
Modern Dog,
Seattle, Washington

ART DIRECTOR:
Vittorio Costarella

DESIGNERS/
ILLUSTRATORS:
Vittorio Costarella

(T-shirt), Robynne Raye
(dish towel)

PRINTING PROCESS:
Silkscreen

PURPOSE: Retail sale

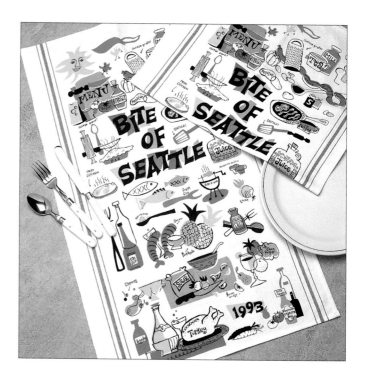

Right: Dish towels.

The Red Balloon Co. (Promotions)

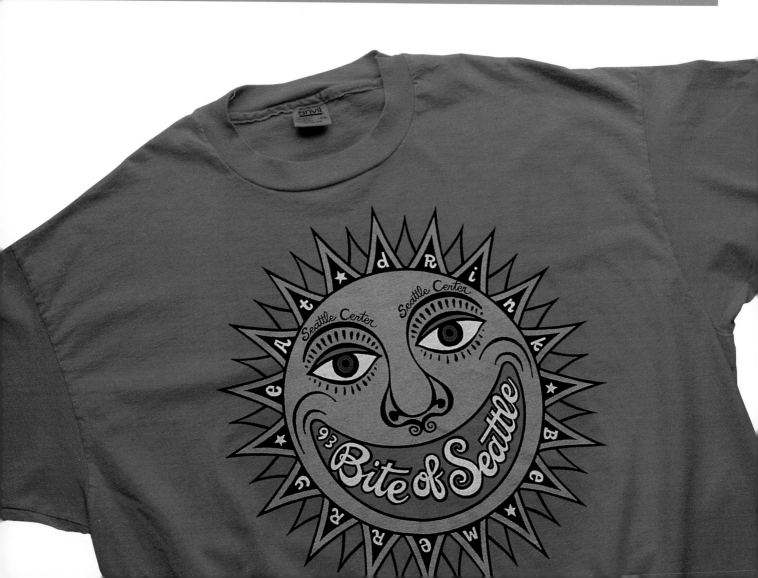

DESIGN FIRM:

Modern Dog,

Seattle, Washington

DESIGN DIRECTOR/

ILLUSTRATOR:

Vittorio Costarella

ART DIRECTORS:

Vittorio Costarella,

Al Parisi

PRINTING PROCESS:

Silkscreen

PURPOSE: Retail sale

Fremont Fair (Annual Summer Solstice Celebration)

Below: Limited-edition magnet.

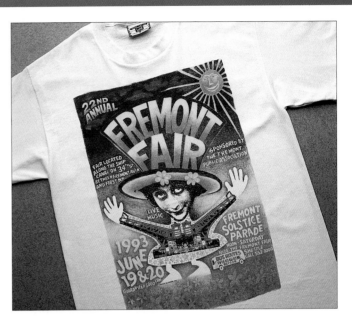

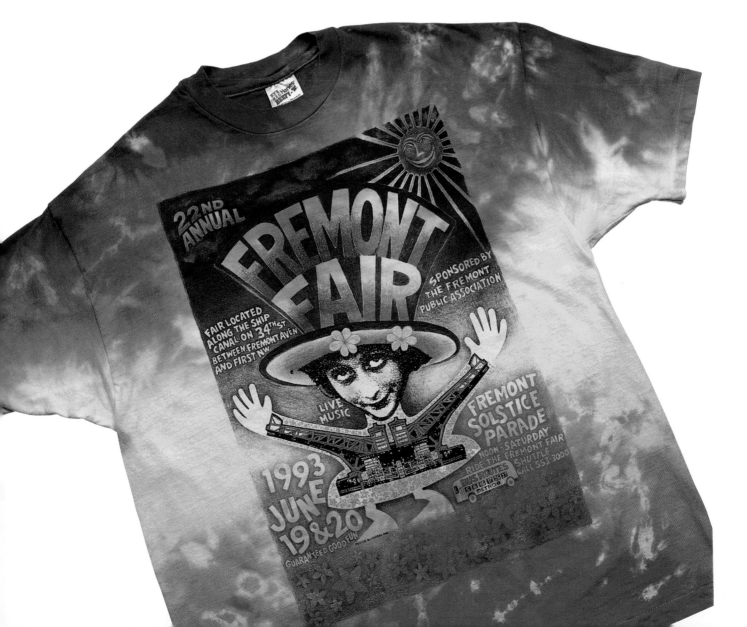

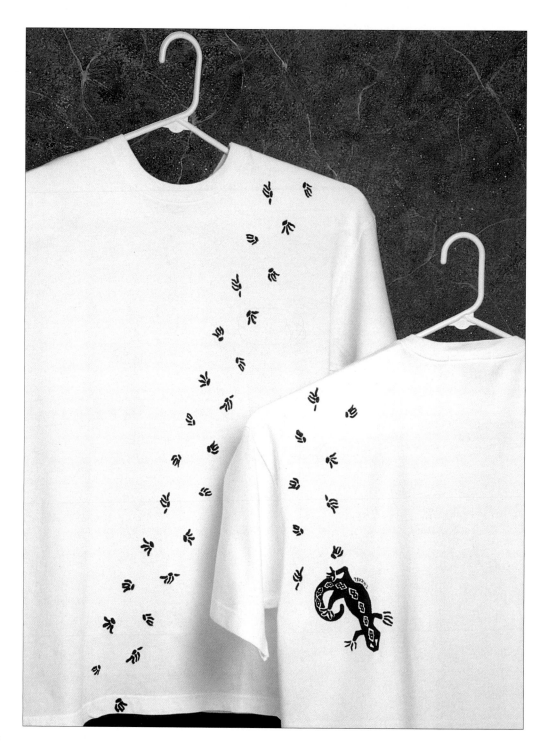

ART DIRECTOR/

DESIGNER/ILLUSTRATOR:

Todd Nickel,

Darien, Connecticut

QUANTITY: 50

PRINTING PROCESS:

Block printed

PURPOSE: Self-promotion

Todd Nickel

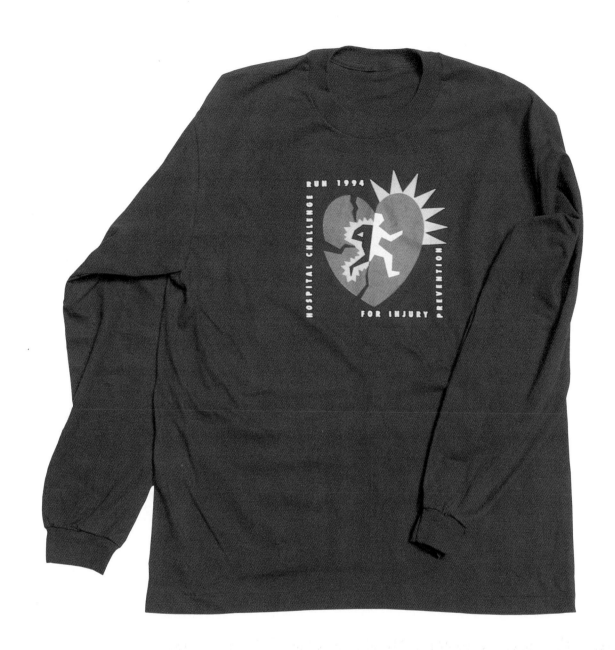

RUN 1994
HOSPITAL CHALLENGE
FOR INJURY PREVENTION

Provenant Trauma Unit Hospital Benefit Run

DESIGN FIRM:

David Warren Design,

Denver, Colorado

ART DIRECTOR:

David Warren

DESIGNERS:

David Warren,

Elise Lansdon

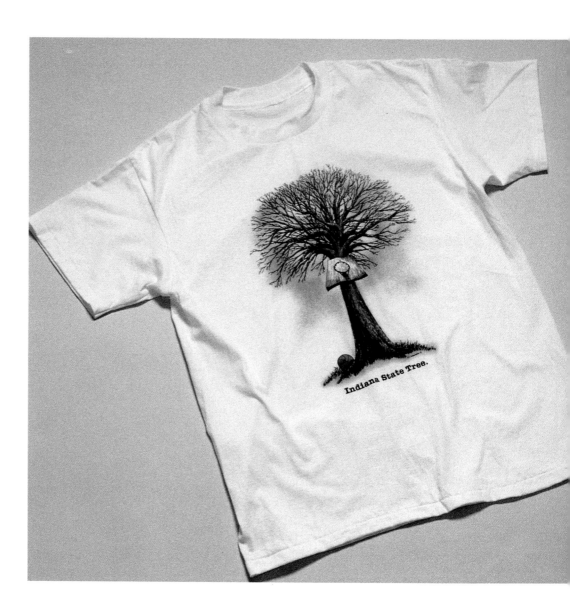

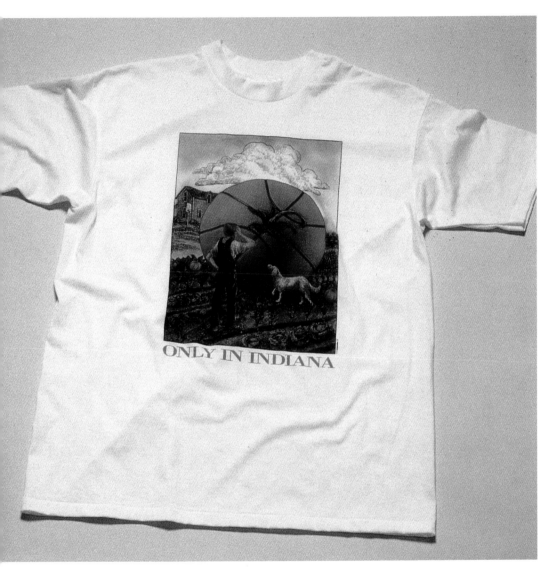

ONLY IN INDIANA

AGENCY:

Cranfill Advertising,

Indianapolis, Indiana

ART DIRECTOR:

Scott Willy

DESIGNER: Kirk Nugent

ILLUSTRATOR:

Clint Hansen

PRINTER: Concept Prints

PRINTING PROCESS:

4-color

PURPOSE: To promote

Indiana basketball, for

sale at retail outlets

throughout the state.

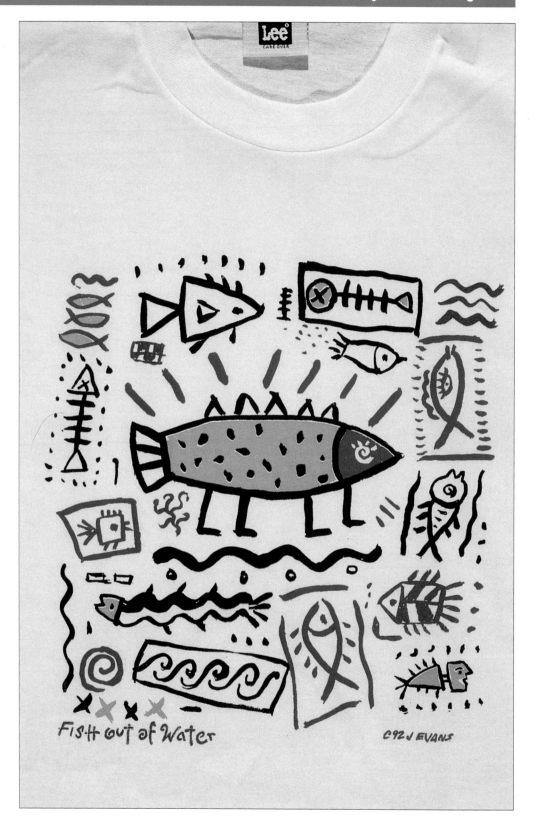

DESIGN FIRM:

Sibley/Peteet Design,

Dallas, Texas

ART DIRECTOR/

DESIGNER/ILLUSTRATOR:

John Evans

PURPOSE: Retail sale

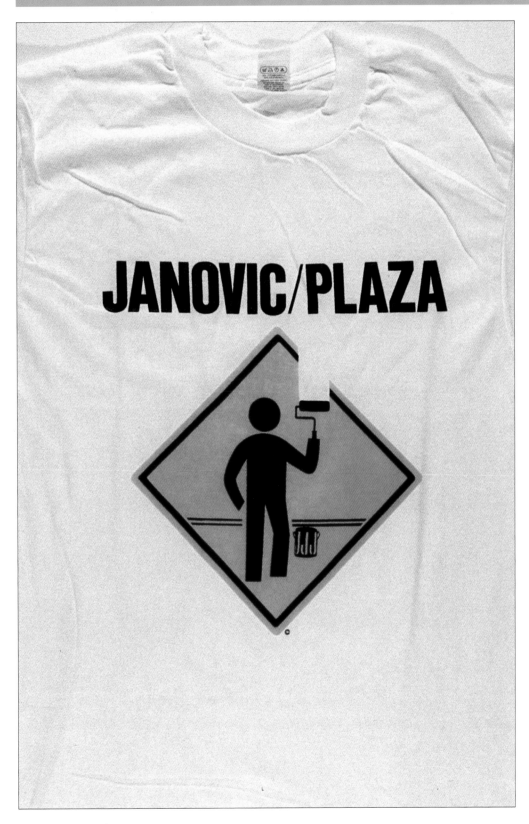

ART DIRECTOR/

ILLUSTRATOR:

Cathy Hull,

New York, New York

PURPOSE: Promotional

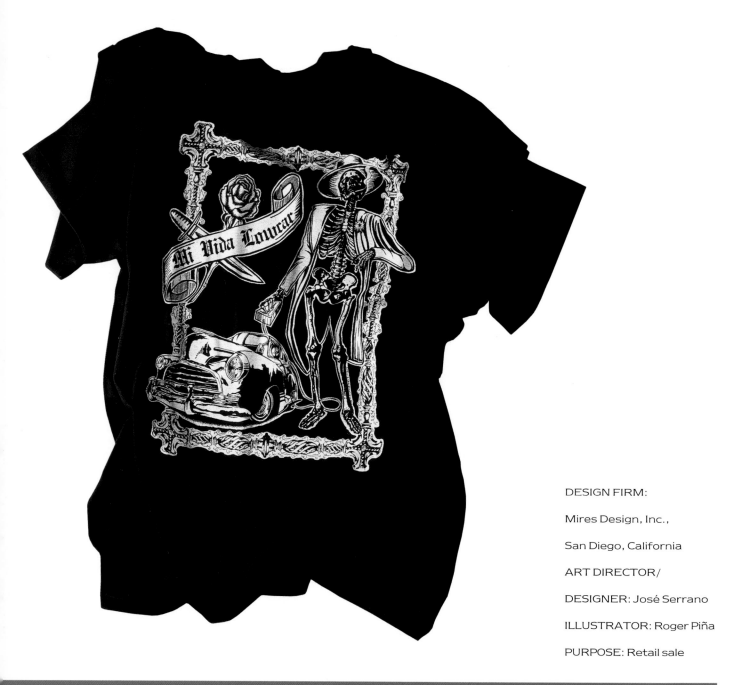

DESIGN FIRM:

Mires Design, Inc.,

San Diego, California

ART DIRECTOR/

DESIGNER: José Serrano

ILLUSTRATOR: Roger Piña

PURPOSE: Retail sale

Chingones (Clothing Manufacturer)

Phinney Design, Inc.

DESIGN FIRM:

Phinney Design, Inc.,

Seattle, Washington

ART DIRECTORS:

Leslie Phinney,

Karl Bischoff

DESIGNER/ILLUSTRATOR:

Dean Hart

PURPOSE: To promote

corporate participation in

Northwest AIDS walk.

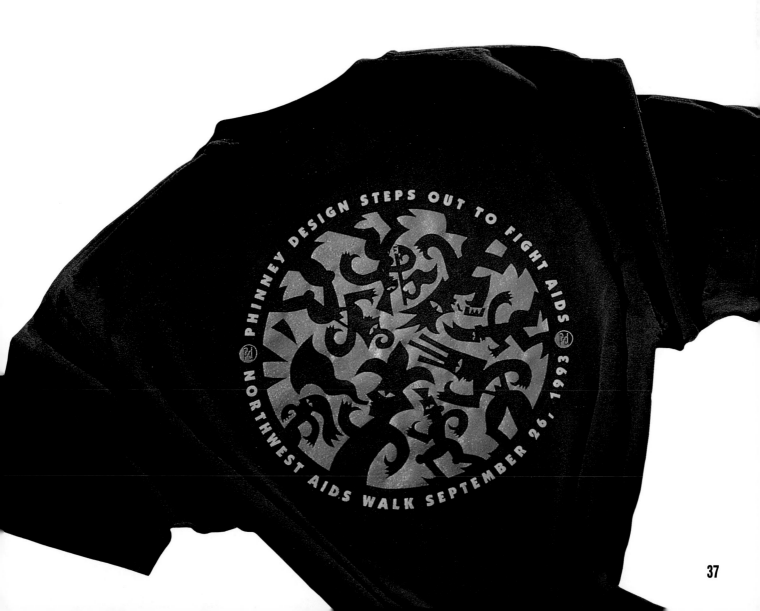

Front.

Back.

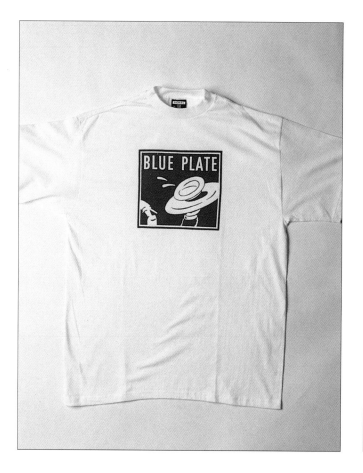

ART DIRECTORS:

Eileen Rosenthal,

Marc Rosenthal,

Malden Bridge, New York

ILLUSTRATOR:

Marc Rosenthal

DESIGNER:

Eileen Rosenthal

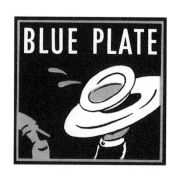

QUANTITY: 480 shirts

PRINTING PROCESS:

Silkscreen

PURPOSE: Promotional

WGBH/Learningsmith (Channel 2)

DESIGN FIRM:

WGBH Design,

Boston, Massachusetts

ART DIRECTOR/

DESIGNER: Chris Pullman

PHOTOGRAPHER:

Tom Sumida

QUANTITY: 200

PRINTING PROCESS:

Silkscreen gray and black

ink with hit of white;

image shot as duotone

PURPOSE: Promotional

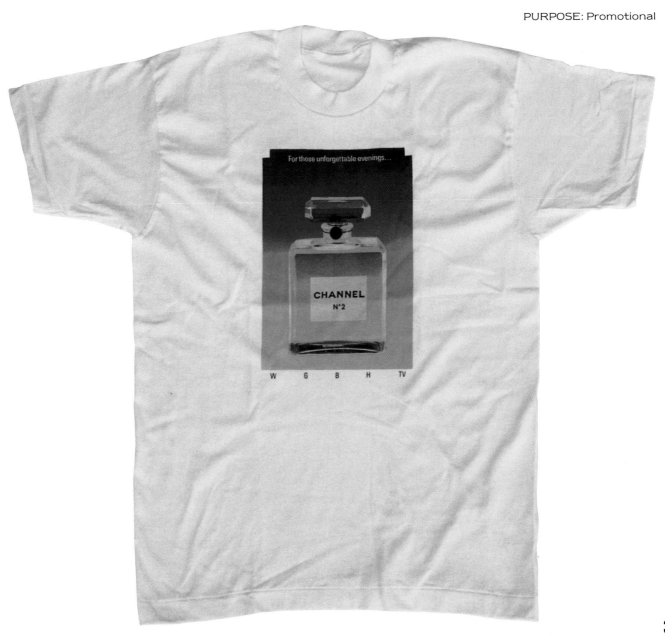

Bikini Yacht Club

Outdoor waterfront night club on the Mississippi River.

DESIGN FIRM: Creative Pig Minds, Rockford, Illinois

DESIGNER/ILLUSTRATOR: Brian D. Endl

BUDGET: $2000 (initial order)

QUANTITY: 250 (initial order)

PRINTING PROCESS: Silkscreen, waterbase inks

PURPOSE: Retail sale

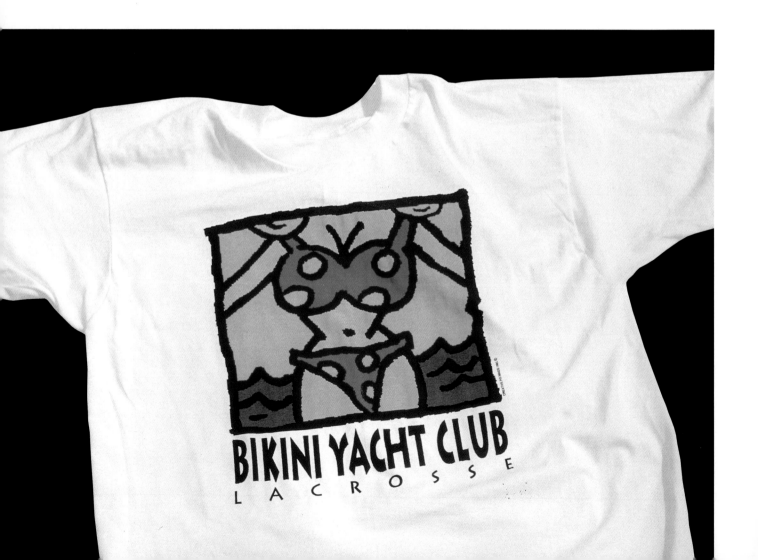

Adobe Systems (Computer Software)

DESIGN FIRM:

John Ritter Illustration,

San Francisco, California

ART DIRECTOR/

DESIGNER: Russell Brown

ILLUSTRATOR:

John Ritter

PURPOSE: Promotional

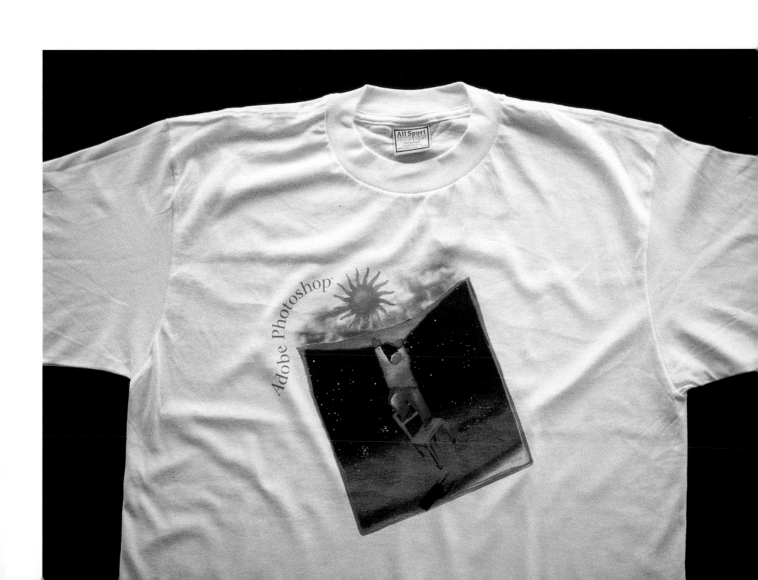

DESIGN FIRM:

Shoebox Greetings,

Kansas City, Missouri

ART DIRECTOR:

Mike Willard

ILLUSTRATOR:

Peter Martin

COPYWRITER:

DeeAnn Stewart

PURPOSE: Retail sale

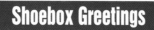

Shoebox Greetings

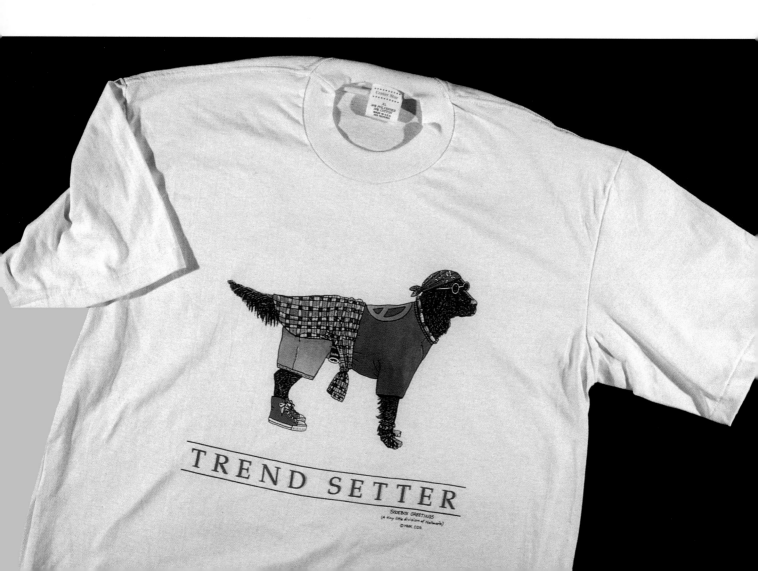

Bay Ballet Theater

DESIGN FIRM:

Altman Meder Lawrence

Hill, Tampa, Florida

ART DIRECTOR:

Ron Roman

ILLUSTRATOR:

Jim Newport

BUDGET: Pro bono

QUANTITY: 1500

PRINTING PROCESS:

Silkscreen

PURPOSE: Fundraiser

sold at performances

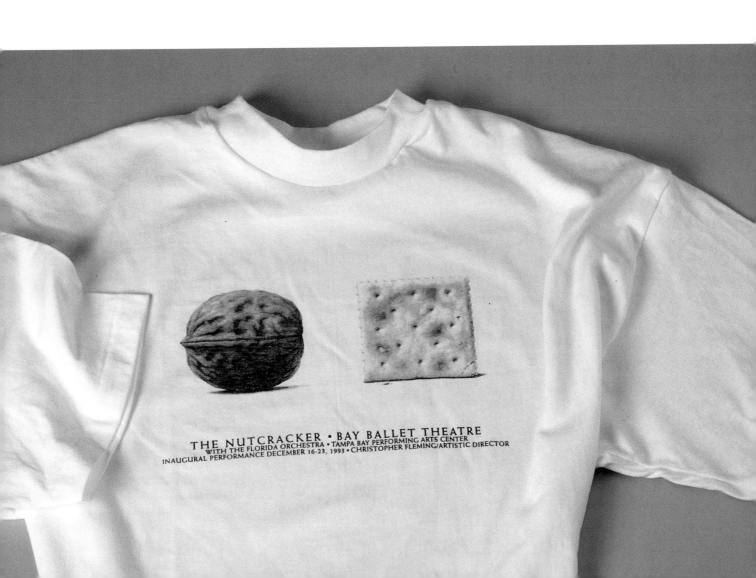

THE NUTCRACKER • BAY BALLET THEATRE
WITH THE FLORIDA ORCHESTRA • TAMPA BAY PERFORMING ARTS CENTER
INAUGURAL PERFORMANCE DECEMBER 16-23, 1993 • CHRISTOPHER FLEMING/ARTISTIC DIRECTOR

DESIGN FIRM:

Crazy Shirts, Inc.,

Aiea, Hawaii

ART DIRECTOR:

Allen Adler

DESIGNER: Ches Abing

PRINTING PROCESS:

Silkscreen using water-

based inks

PURPOSE: Retail sale

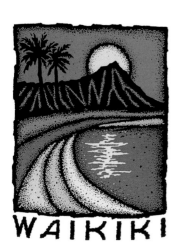

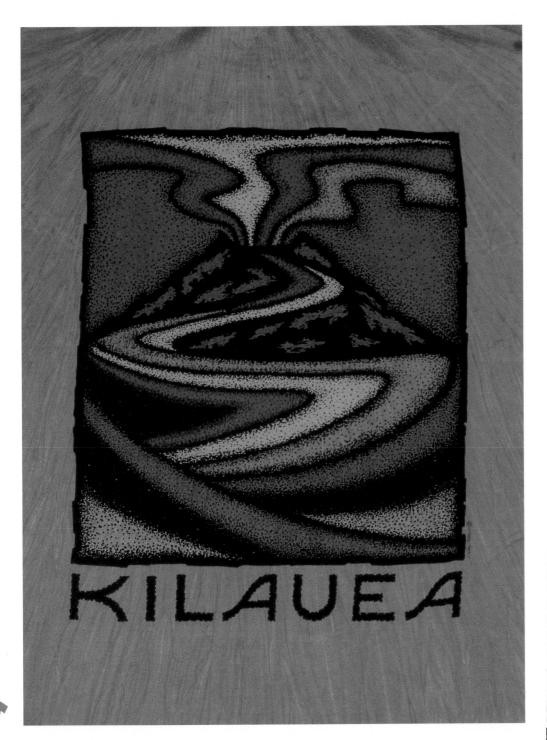

KILAUEA

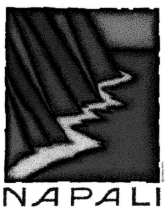

NAPALI

Crazy Shirts, Inc. (T-shirt Manufacturer)

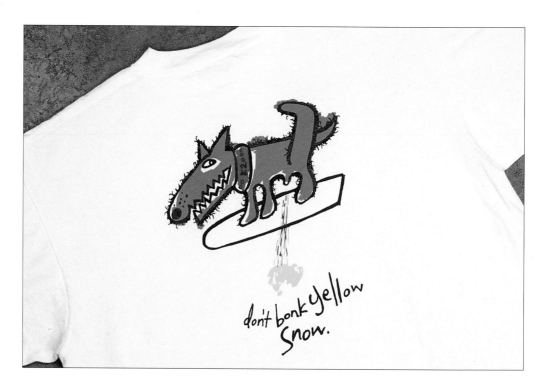

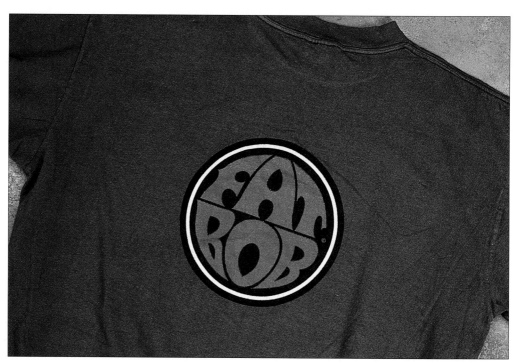

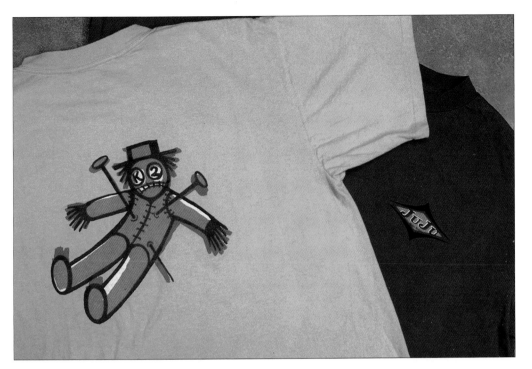

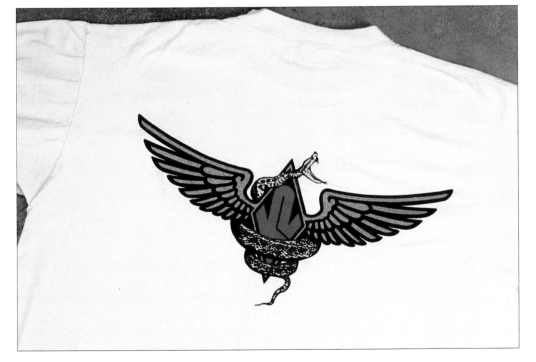

DESIGN FIRM:
Modern Dog,
Seattle , Washington
ART DIRECTORS:
Robynne Raye,
Brent Turner, Luke Edgar
DESIGNERS:
Robynne Raye (Yellow
Snow), Vittorio Costarella
(Fat Bob, JuJu, Wings),
Michael Strassburger
(Wings)
ILLUSTRATORS:
Robynne Raye (Yellow
Snow), Vittorio Costarella
(Fat Bob, JuJu, Wings)
PRINTING PROCESS:
Silkscreen
PURPOSE: To create an
image/attitude for client

K2 Snowboards (Snowboard Manufacturers)

DESIGN FIRM:

The Knape Group,

Dallas, Texas

DESIGNER: Les Kerr,

James Michael Starr

ILLUSTRATOR: Tim Jessell

PURPOSE: Promotional

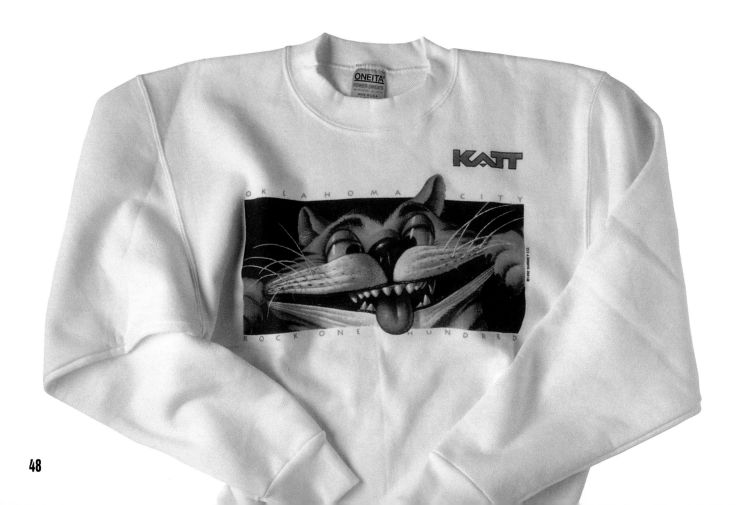

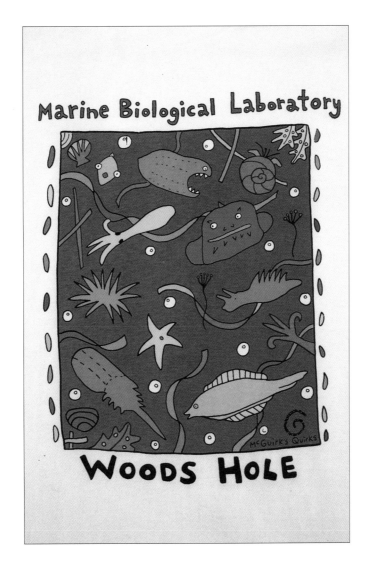

DESIGN FIRM:

McGuirk's Quirks,

Portsmouth,

New Hampshire

DESIGNER:

Leslie McGuirk

PRINTING PROCESS:

Hand silkscreened with

water- based inks

PURPOSE: Fundraiser for

research projects

Woods Hole Marine Biological Lab

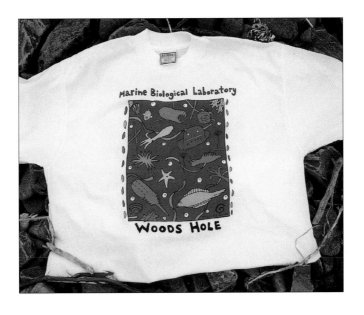

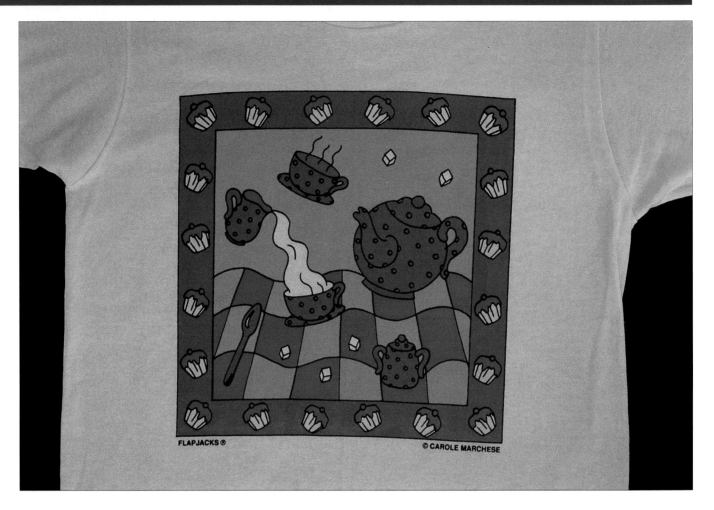

Hangtags.

Printer of children's
T-shirts.
DESIGN FIRM:
Marchese Design,
Southport, Connecticut
DESIGNER/ILLUSTRATOR:
Carole Marithe Marchese
PRINTING PROCESS:
Silkscreen
PURPOSE: Retail sale

DESIGN FIRM:

The Bozarts Press/

Montana State University

School of Art,

Bozeman, Montana

ART DIRECTORS:

Anne Garner,

Jeffrey Conger

DESIGNER/ILLUSTRATOR:

Raelene Mercer

BUDGET: $210

QUANTITY: 20

(original edition)

PRINTING PROCESS:

Silkscreen

PURPOSE: Promotion/

class assignment; each

advanced student created

a design using a cow and

the words Bozarts Press,

then all the design

students voted on the one

to be printed.

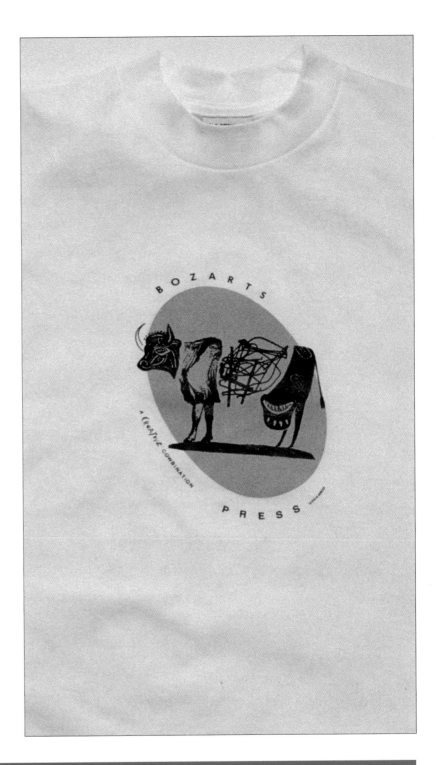

The Bozarts Press

Front.

DESIGN FIRM:

The Kottler Caldera Group,

Phoenix, Arizona

ART DIRECTORS:

Paul Caldera, Dave Kottler

DESIGNER/ILLUSTRATOR:

Bart Welch

PURPOSE: Promotional

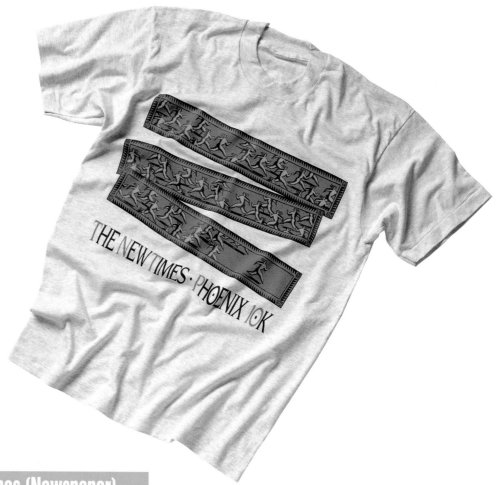

The New Times (Newspaper)

Back.

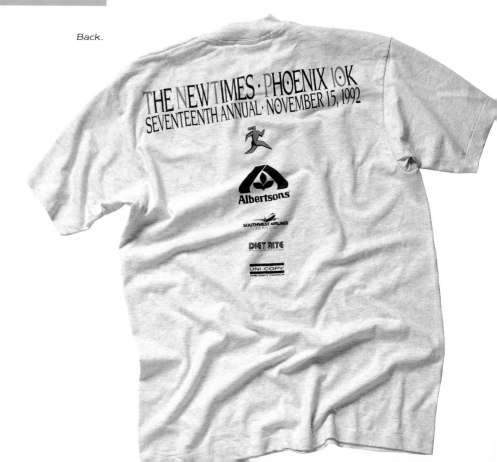

DESIGNER/ILLUSTRATOR:

Ray Troll,

Ketchikan, Alaska

ART DIRECTOR:

Scott Duttry

PRINTING PROCESS:

Original linoleum block,

silkscreen

PURPOSE: Retail sale

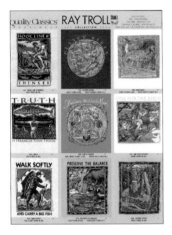

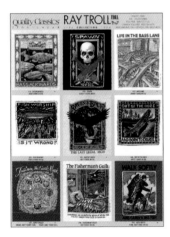

Above: other Ray Troll T-shirt designs manufactured by Quality Classics Sportswear.

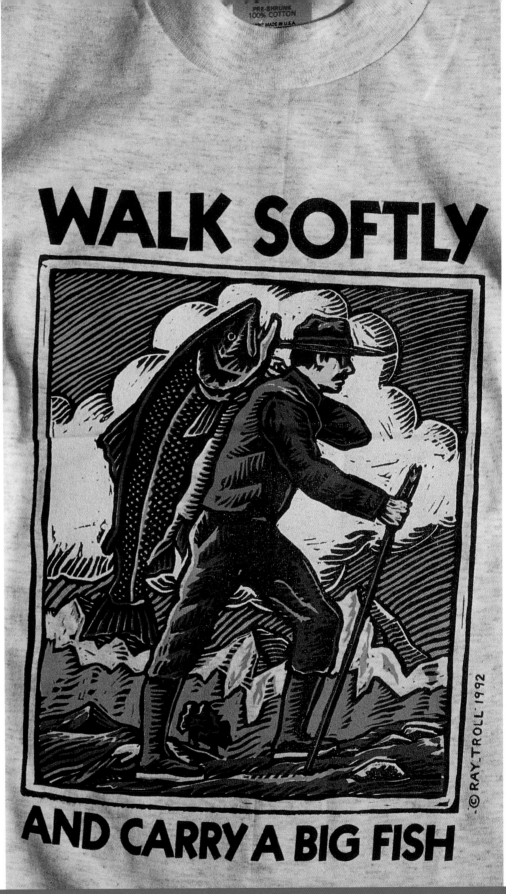

Front.

PHOTOGRAPHY 501 N. COLLEGE STREET
FONE → 704.377.4217 CHARLOTTE, NC
704.375.1908 ← FAXX 2 · 8 · 2 · 0 · 2

Front of business card.

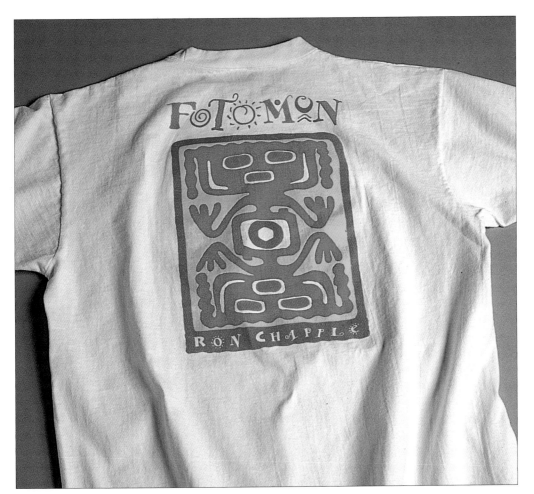

DESIGN FIRM:

Mervil Paylor Design,

Charlotte, North Carolina

DESIGNER:

Mervil M. Paylor

QUANTITY: 100

PRINTING PROCESS:

Silkscreen

PURPOSE: Promotional

Back.

Ron Chapple Photography

Back of business card.

DESIGNER:

Lynn Anderson,

San Diego, California

BUDGET: $200

QUANTITY: 4

PRINTING PROCESS:

Custom color transfer

PURPOSE: Team

identification at world

championship

competition.

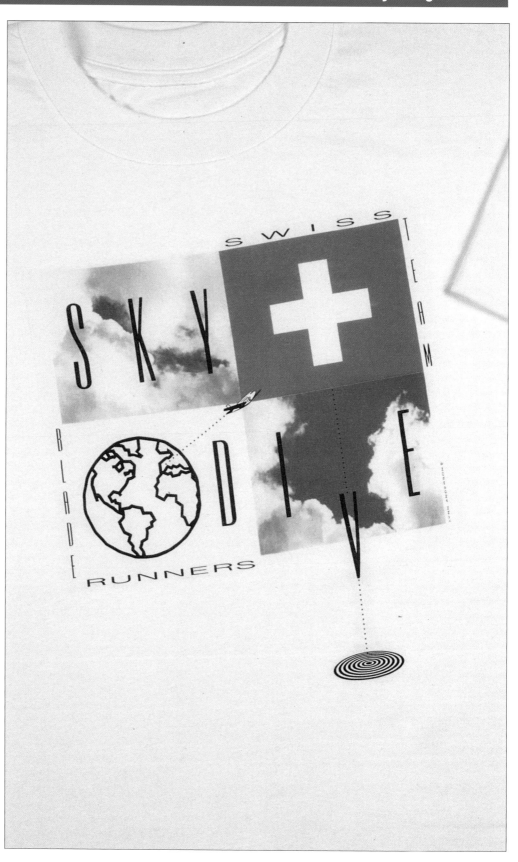

DESIGN FIRM:

Eisenberg and Associates,

Dallas, Texas

CREATIVE DIRECTOR:

Arthur Eisenberg

DESIGNER/ILLUSTRATOR:

Mike Fisher

AGENCY: Cherri Oakley/

Oakley & Associates

PURPOSE: To promote

annual benefit run.

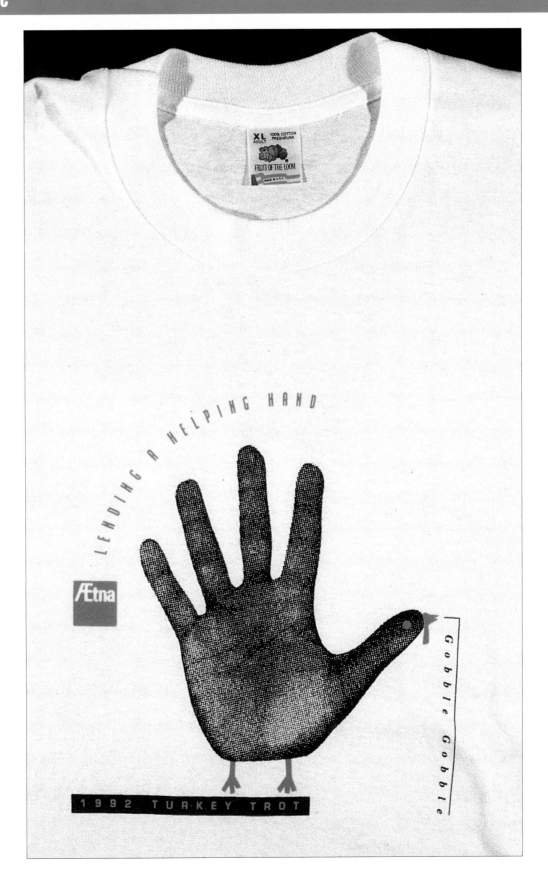

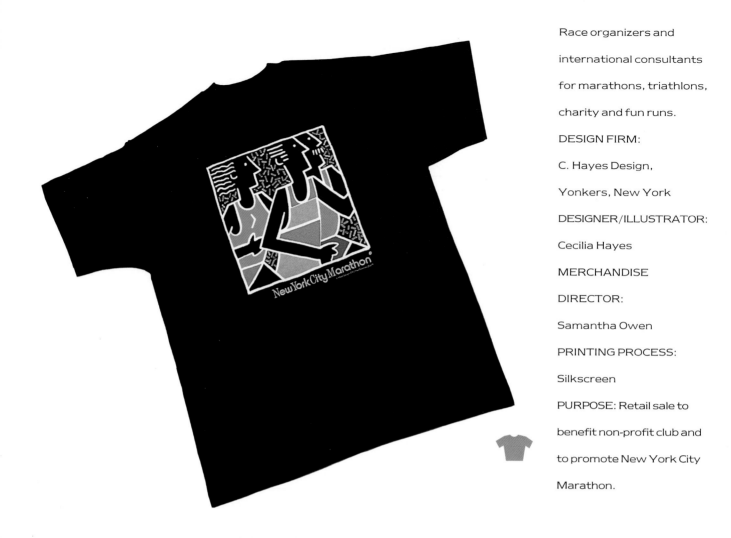

Race organizers and international consultants for marathons, triathlons, charity and fun runs.

DESIGN FIRM:
C. Hayes Design, Yonkers, New York

DESIGNER/ILLUSTRATOR:
Cecilia Hayes

MERCHANDISE DIRECTOR:
Samantha Owen

PRINTING PROCESS:
Silkscreen

PURPOSE: Retail sale to benefit non-profit club and to promote New York City Marathon.

New York Road Runners Club

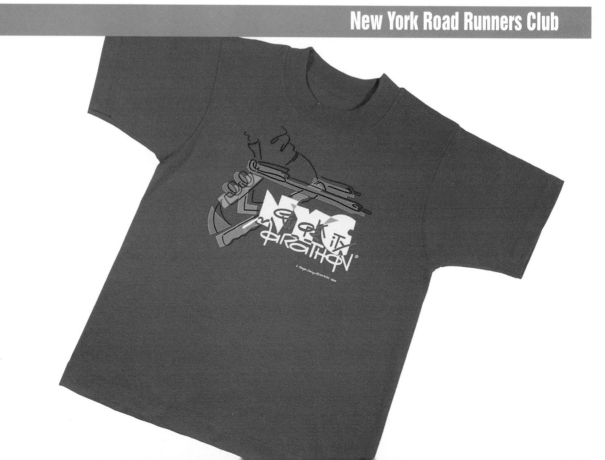

DESIGN FIRM:

Ludwig Design, Inc.,

Kansas City, Missouri

ART DIRECTOR/

DESIGNER/ILLUSTRATOR:

Kelly Ludwig

BUDGET: Cost + $500 fee

QUANTITY: 200

PRINTING PROCESS:

Silkscreen

PURPOSE: To promote a

music festival held at a

farm outside of Lawrence,

Kansas, and also to help

promote a concert

promotion business

featuring alternative/

college bands.

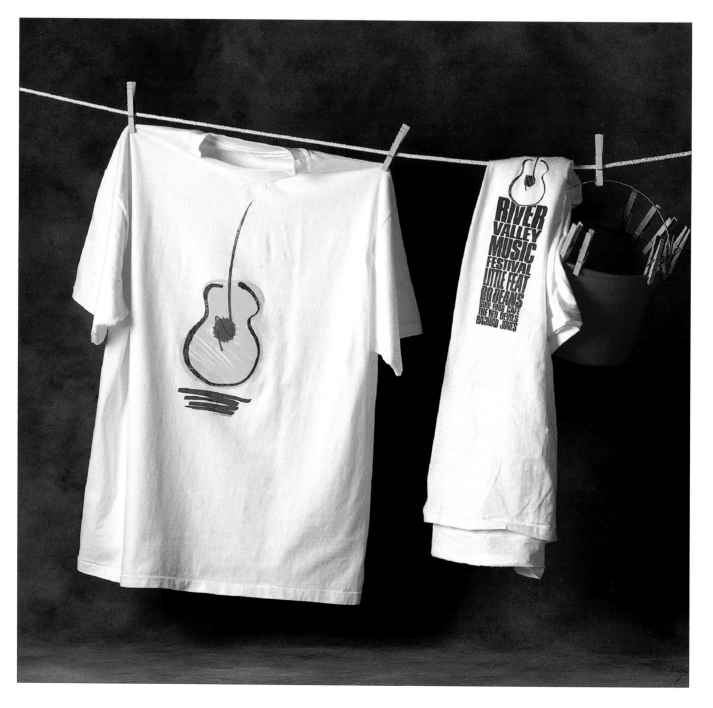

DESIGN FIRM:

Crocker, Inc.,

Brookline, Massachusetts

ART DIRECTOR/

DESIGNER: Bruce Crocker

ILLUSTRATOR:

Mark Fisher

COPYWRITER:

Grant Sanders

QUANTITY: 500

PRINTING PROCESS:

Silkscreen

PURPOSE: Tradeshow

game prize and general

promotion.

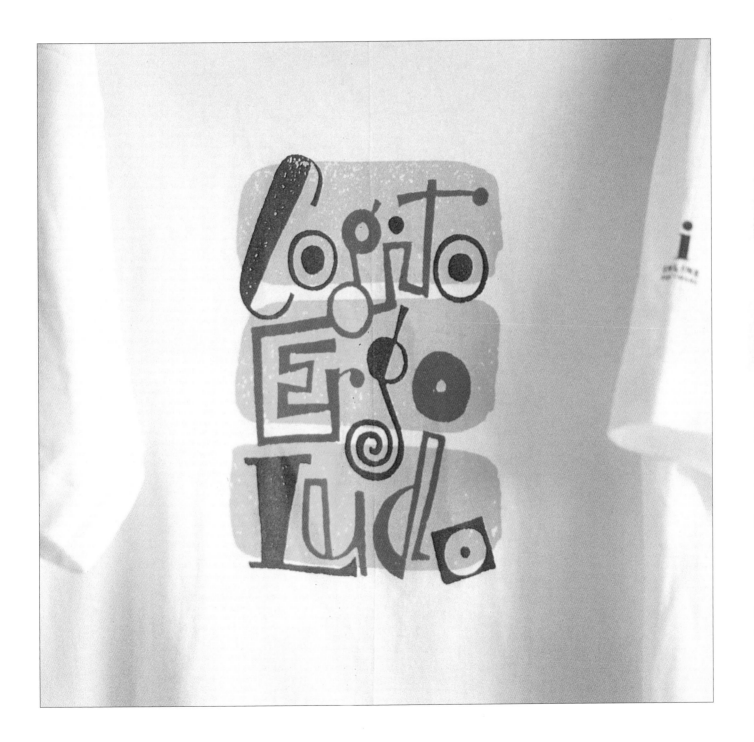

This page and opposite, top:
other T-shirt designs for the
same client.

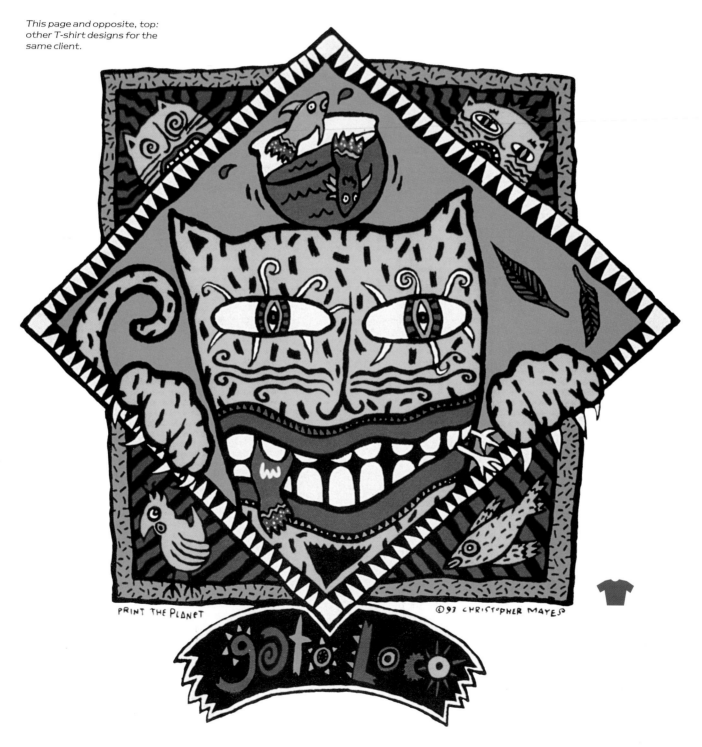

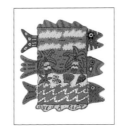

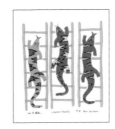

DESIGN FIRM:

Christopher Mayes Design,

Houston, Texas

DESIGNER/ILLUSTRATOR:

Christopher Mayes

PURPOSE: Retail sale

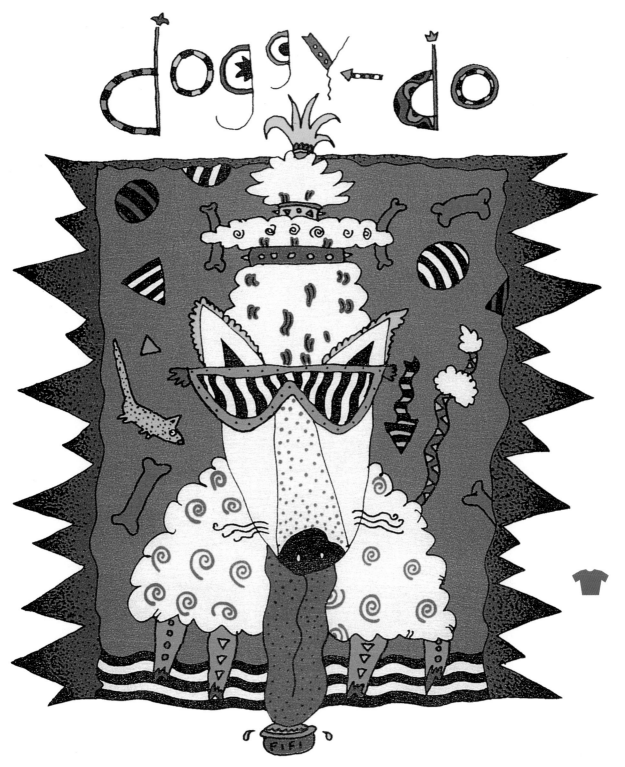

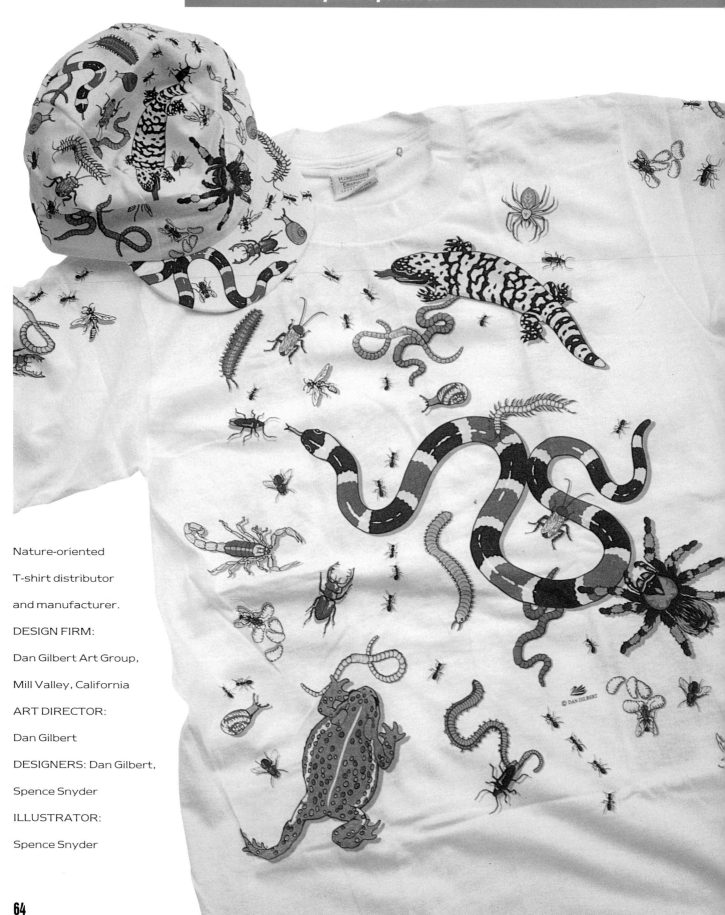

Nature-oriented
T-shirt distributor
and manufacturer.
DESIGN FIRM:
Dan Gilbert Art Group,
Mill Valley, California
ART DIRECTOR:
Dan Gilbert
DESIGNERS: Dan Gilbert,
Spence Snyder
ILLUSTRATOR:
Spence Snyder

DESIGN FIRM:
Francis Design,
Portsmouth,
New Hampshire

ART DIRECTOR/
DESIGNER: Joanne Francis

ILLUSTRATOR:
Clyde Duensing III

BUDGET: $6800

(design/production/
printing)

QUANTITY: 960
(sold out at event)

PRINTING PROCESS:
4-color silkscreen

PURPOSE: Staff uniform
for event and souvenir
piece for sale.

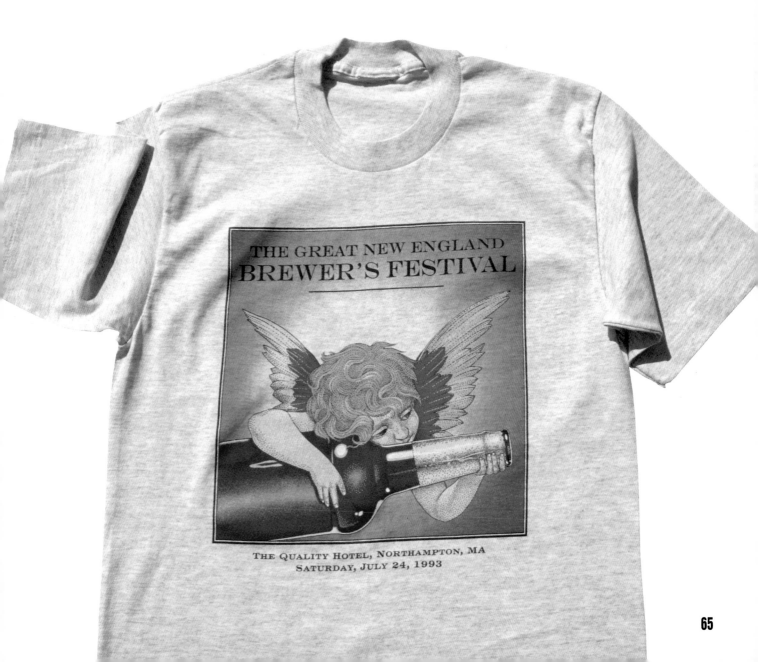

This is a T-SHIRT.

A temporary tattoo. A cotton canvas. A perambulating poster. Trademark of STANLEY KOWALSKI, John "Bowser" Bauman, Arthur Fonzerelli, and the shadetree mechanic. It's universal weekend wear. Something to throw on but never to throw away. A cigarette pack holder. A souvenir. A concert promotion. A gift. THE TUXEDO OF THE SOUTH. A billboard. A bib. A boast. A conviction. A wearable statement and a wardrobe staple. Rebellious on James Dean, Peter Fonda, skate rats, and rock and rollers. Conformist on fraternity brothers, sorority sisters, jocks, and plumbers. It's a softball uniform. A cleaning outfit. A dust rag. A car polisher. Typical garb of the Barcolounger-riding, brew-slugging Monday Night football buff. Aqueous purveyor of mammiferous protuberances. It's an undershirt. An overshirt. A nightie. A hand-me-down. One of 1,000 guaranteed fifth prizes. And the official shirt of the 4th Annual Thomas & Betts and Thompson & Company Volleyball Match and Family Picnic.

DESIGN FIRM:
Thompson & Company,
Memphis, Tennessee

ART DIRECTOR/
ILLUSTRATOR: kp

CREATIVE DIRECTORS:
Trace Hallowell,
Michael H. Thompson

COPYWRITER:
Sheperd Simmons

PRODUCTION:
Helen McLain

QUANTITY: 100

PRINTING PROCESS:
Silkscreen

PURPOSE: Premium and souvenir for clients and agency staff attending annual volleyball/barbecue family day. It's a fashion statement, literally.

Thompson & Company (Ad Agency)

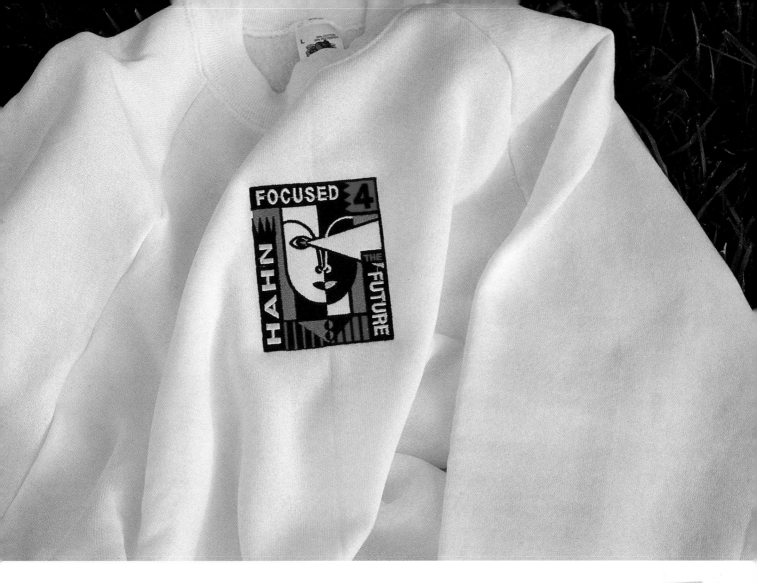

DESIGN FIRM:

Hahn Advertising & Design,

San Diego, California

ART DIRECTOR/

DESIGNER/ILLUSTRATOR:

Sal Barajas

PURPOSE: To promote

the annual corporate

marketing conference/

training seminar.

Right: corporate personnel directory distributed at the seminar.

The Hahn Company (Shopping Center Owners/Managers)

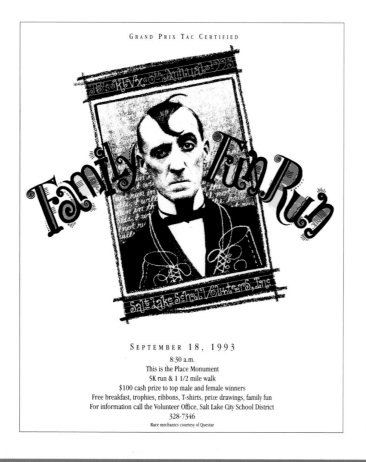

GRAND PRIX TAC CERTIFIED

Family Fun Run

Salt Lake School Volunteers, Inc

SEPTEMBER 18, 1993
8:30 a.m.
This is the Place Monument
5K run & 1 1/2 mile walk
$100 cash prize to top male and female winners
Free breakfast, trophies, ribbons, T-shirts, prize drawings, family fun
For information call the Volunteer Office, Salt Lake City School District
328-7346
Race mechanics courtesy of Questar

DESIGN FIRM:

Fotheringham, Jensen,

Christensen & Newbold,

Salt Lake City, Utah

ART DIRECTOR/

DESIGNER/ILLUSTRATOR:

Randy Stroman

PURPOSE: To promote

annual fun run.

Left: promotional poster

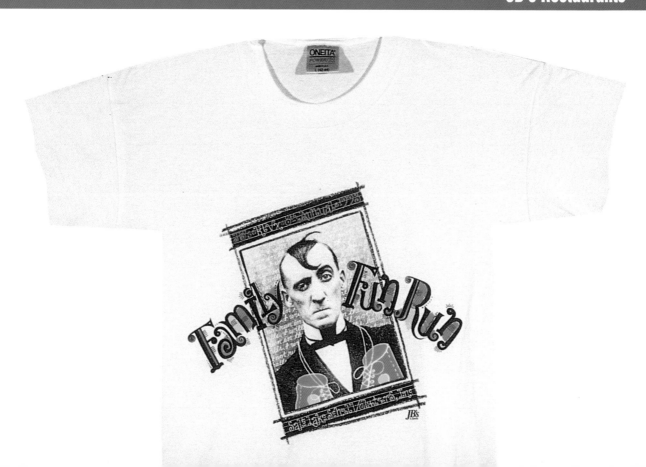

DESIGN FIRM:

DDB Needham

Worldwide Marketing,

Wilton, Connecticut

ART DIRECTOR/

DESIGNER:

Sharon Occhipinti

QUANTITY: 500

PRINTING PROCESS:

Silkscreen

PURPOSE: To promote

Colombian coffee to the

trade.

*Full-page ad (below) ran in the
International Coffee Congress
Directory.*

Obviously a tasteful affair.

100% Colombian Coffee. The richest coffee in the world.

National Federation of Coffee Growers of Colombia

DESIGN FIRM:

Vaughn/Wedeen Creative,

Albuquerque, New Mexico

ART DIRECTOR/

DESIGNER:

Daniel Michael Flynn

ILLUSTRATORS:

Daniel Michael Flynn,

Bill Gerhold

COMPUTER PRODUCTION:

Chip Wyly

QUANTITY: 250

PRINTING PROCESS:

Silkscreen

PURPOSE: To promote

in-house staff awareness

of the ongoing image

campaign.

Above, left: poster; top: manager's kit; above: promotional video and audio tapes and manuals; left: stationery for the image campaign.

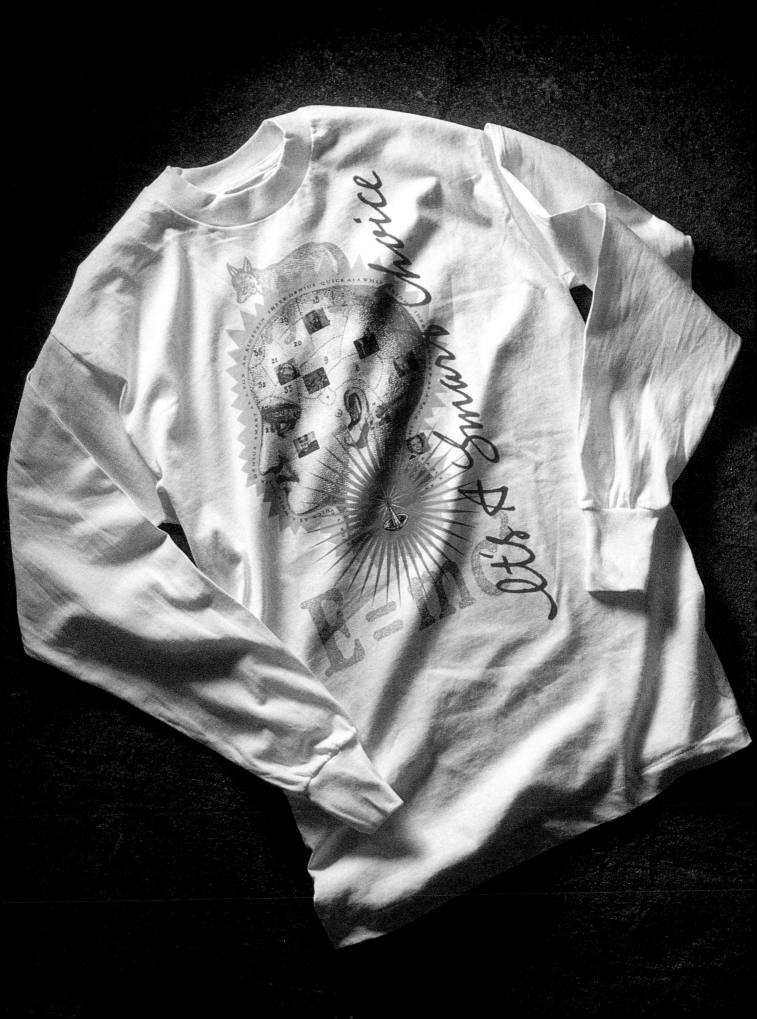

DESIGN FIRM:

Sibley/Peteet Design,

Dallas, Texas

ART DIRECTOR/

DESIGNER/ILLUSTRATOR:

Derek Welch

QUANTITY: 10

PRINTING PROCESS:

Silkscreen

PURPOSE: Limited retail

sale

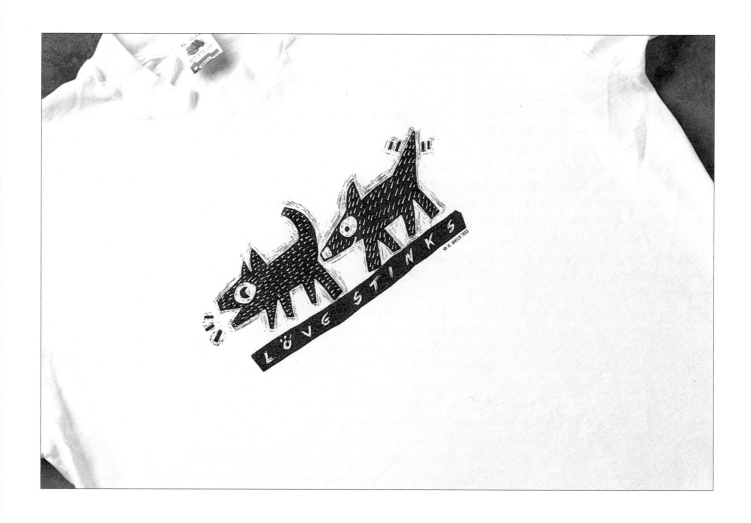

ILLUSTRATOR:

Scott Menchin, New York,

New York

ART DIRECTOR:

Scott Wadler

DESIGNER:

Laurie Hinzman

PRINTING PROCESS:

Silkscreen

PURPOSE: Subscriber

promotion

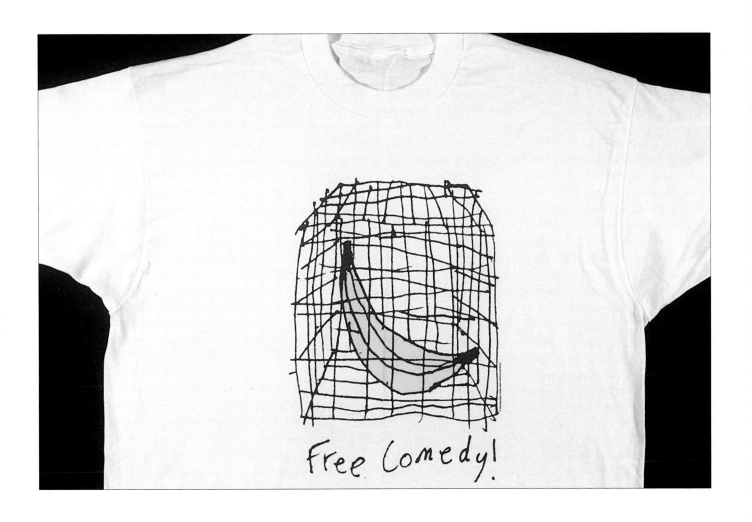

Below: self-promotional brochure and packaging for brochure and T-shirt.

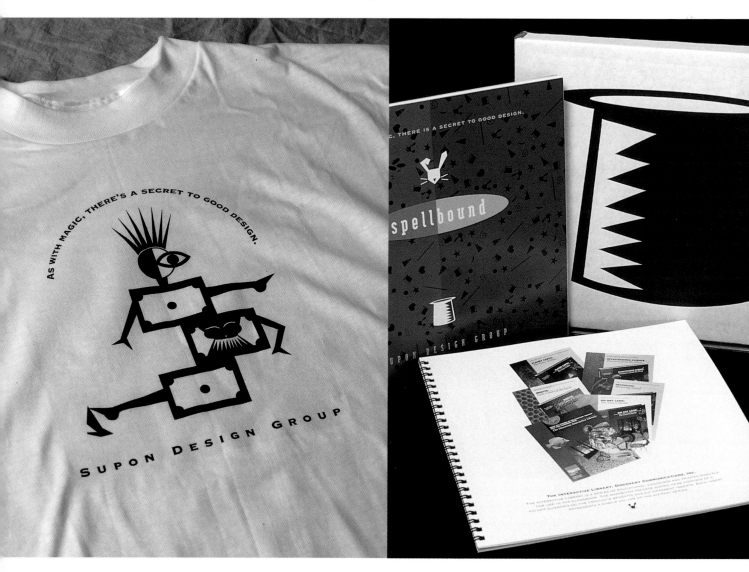

DESIGN FIRM:

Supon Design Group,

Washington, DC

ART DIRECTOR:

Supon Phornirunlit

DESIGNER:

Richard Lee Heffner

BUDGET: $4.50 per shirt

(brochure and box-

printing $7000)

QUANTITY: 2000 T-shirts,

2000 brochures and boxes

PRINTING PROCESS:

Silkscreen for T-shirt,

offset printing for box

and brochure

PURPOSE: Self-promotion

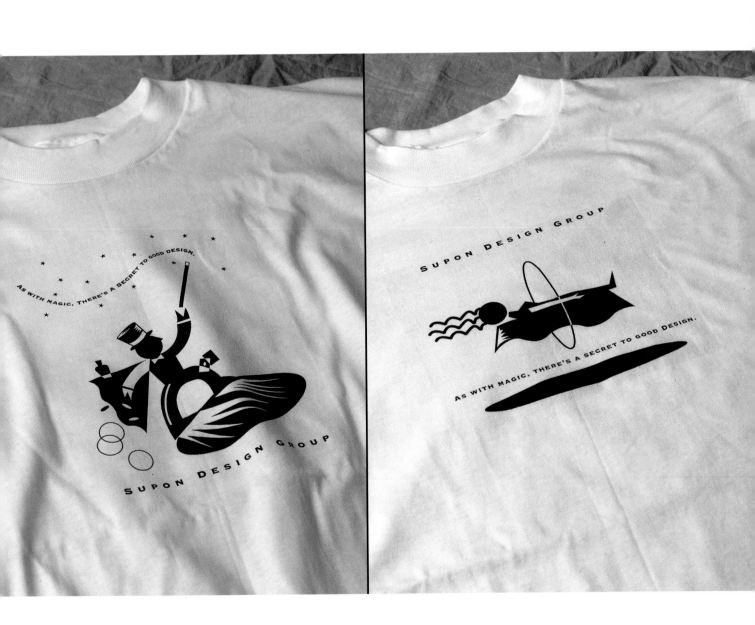

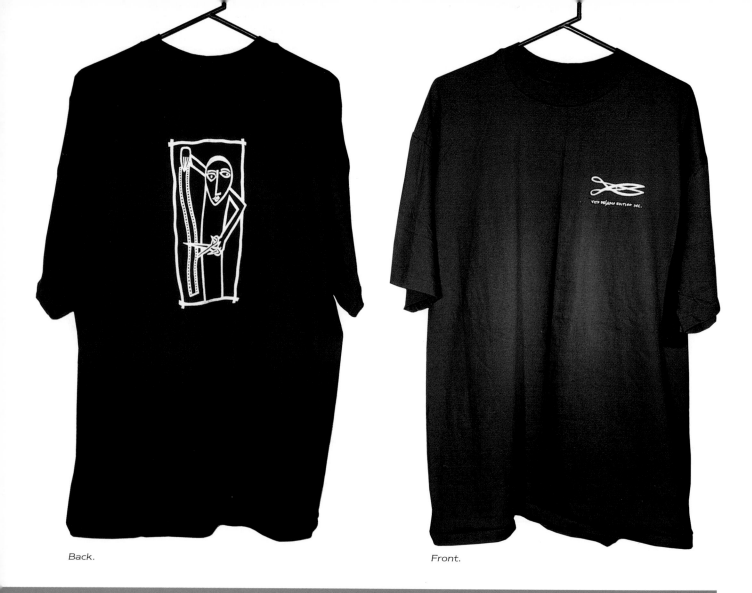

Back.

Front.

Stationery.

ART DIRECTOR/

DESIGNER: Ana C. Pinto,

New York, New York

PURPOSE: Promotional

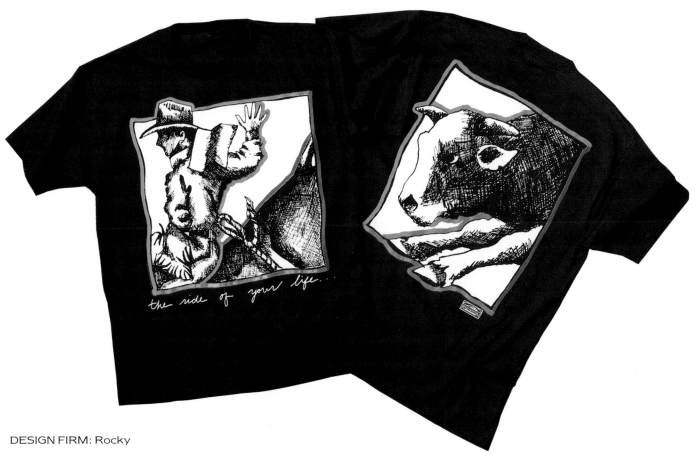

DESIGN FIRM: Rocky

Mountain Clothing Co.,

division of Miller

International, Denver,

Colorado

DESIGNER: Susie Fisher

PRINTING PROCESS:

Over-sized front and back

screen print

PURPOSE: For sale in

western wear retail

stores/catalogs, with the

targeted consumer being

the rodeo enthusiast.

Rocky Mountain Clothing Co.

DESIGN FIRM:

Clifford Selbert Design,

Cambridge, Massachusetts

ART DIRECTOR/

DESIGNER/ILLUSTRATOR:

Lynn Riddle

PRINTER: Mirror Image

BUDGET: Pro bono

PRINTING PROCESS:

Silkscreen

PURPOSE: For distribution

at the Internation Council

policy-making conference.

The message to attendees

was to join together to

make enough noise about

the cause. Shirts later were

used for fundraising.

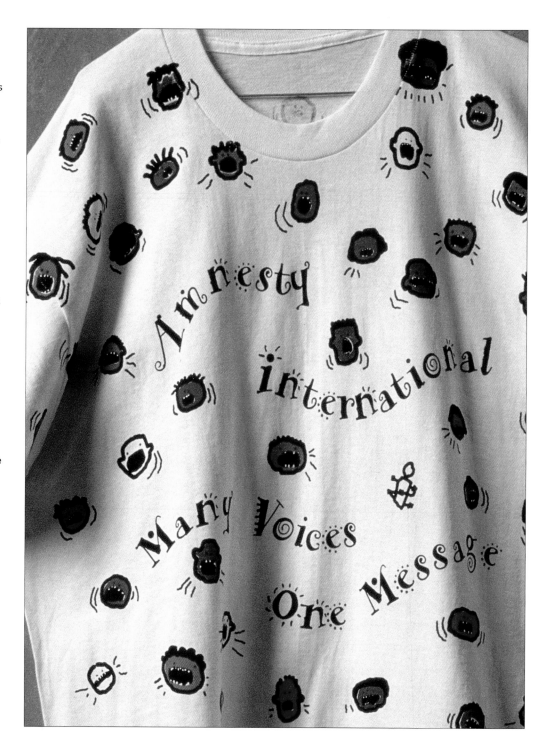

Amnesty International

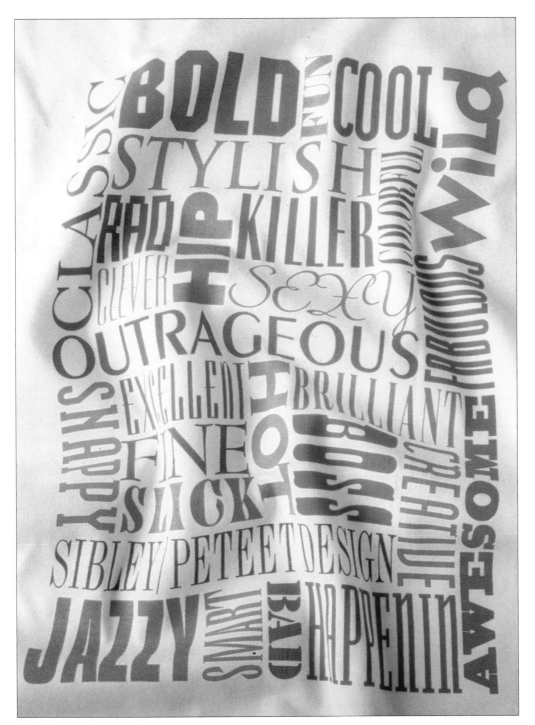

DESIGN FIRM:

Sibley/Peteet Design,

Dallas, Texas

ART DIRECTOR/

DESIGNER: Don Sibley

QUANTITY: 300

PRINTING PROCESS:

Silkscreen

PURPOSE:

Self-promotional holiday

gift to clients, friends and

suppliers.

Sibley/Peteet Design

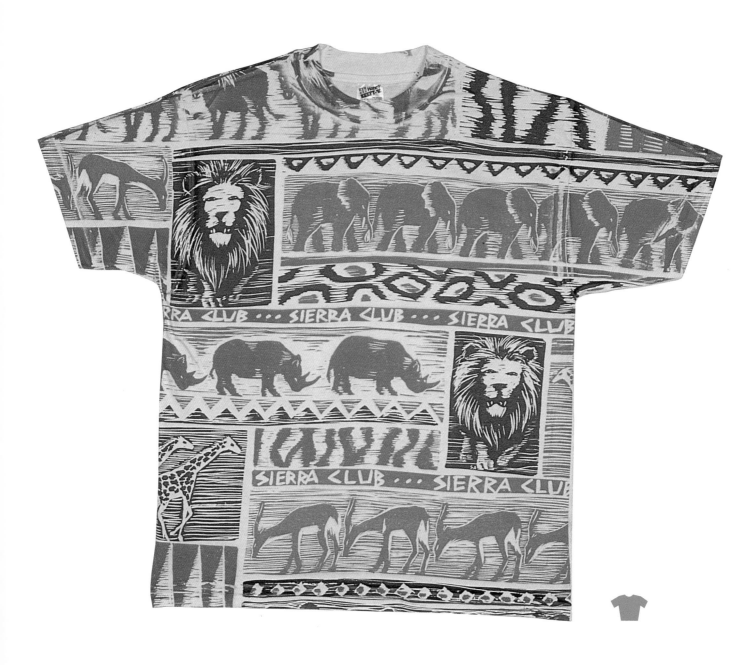

DESIGN FIRM:

Winterland Productions,

San Francisco, California

ART DIRECTOR:

Sandra Horvat Vallely

DESIGNER/ILLUSTRATOR:

Sandy Allnock

PURPOSE: Retail sale

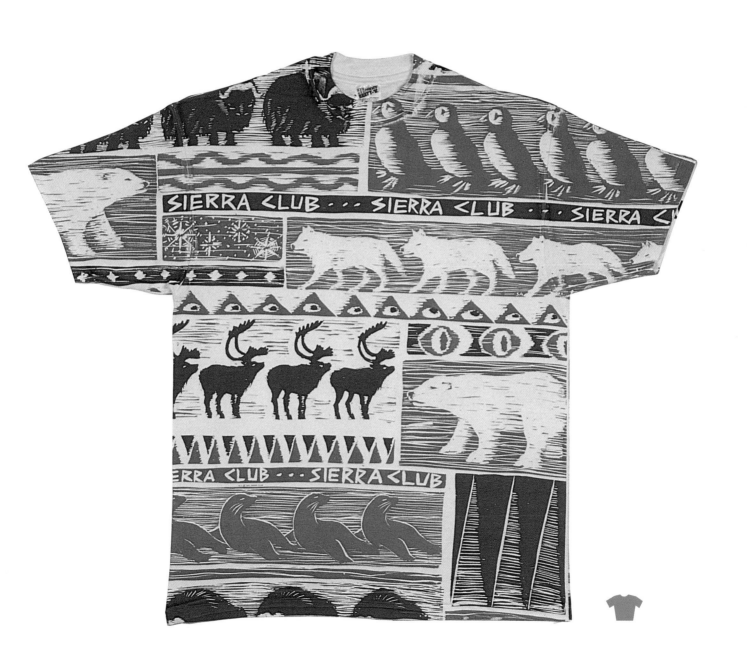

DESIGN FIRM:

Pictogram Studio,

Washington, DC

ART DIRECTOR:

Stephanie Hooton

DESIGNERS:

Stephanie Hooton,

Hien Nguyen

BUDGET: $575.20

QUANTITY: 78

PRINTING PROCESS:

Silkscreen

PURPOSE: Summer

promotion to clients.

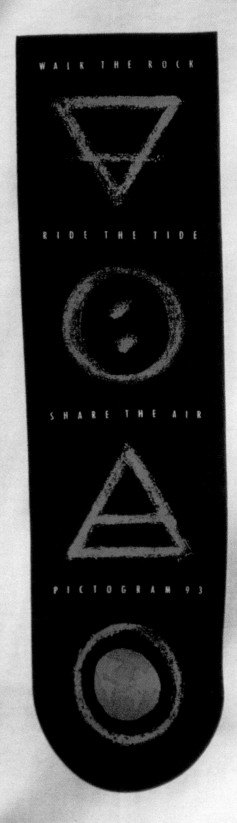

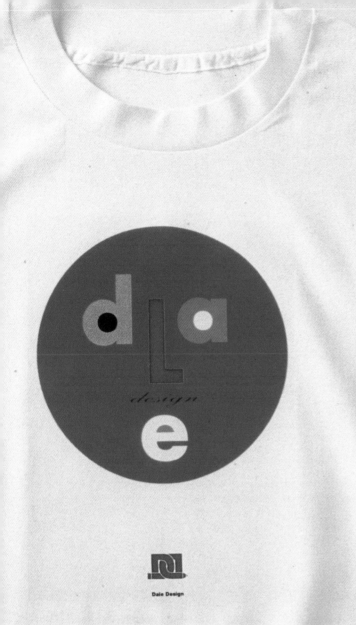

DESIGN FIRM:

Dale Design, Raleigh,

North Carolina

ART DIRECTOR/

DESIGNER: Jeffrey S. Dale

PURPOSE: Client give-away

Dale Design

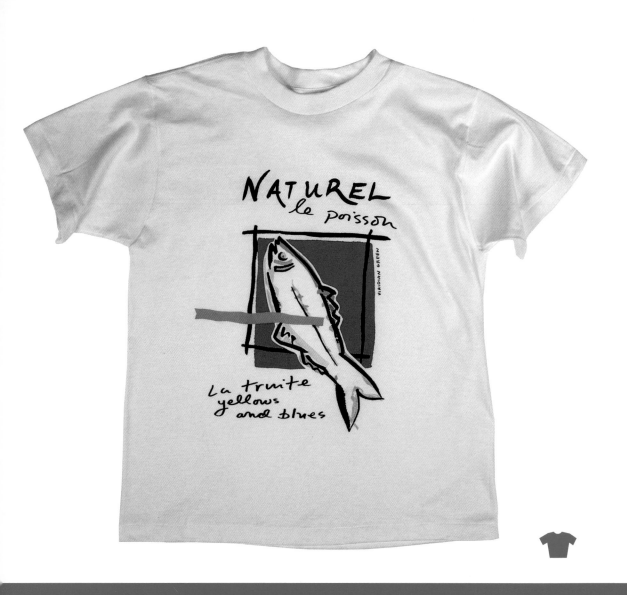

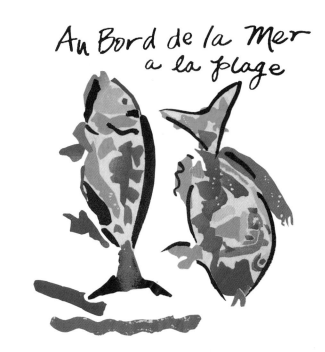

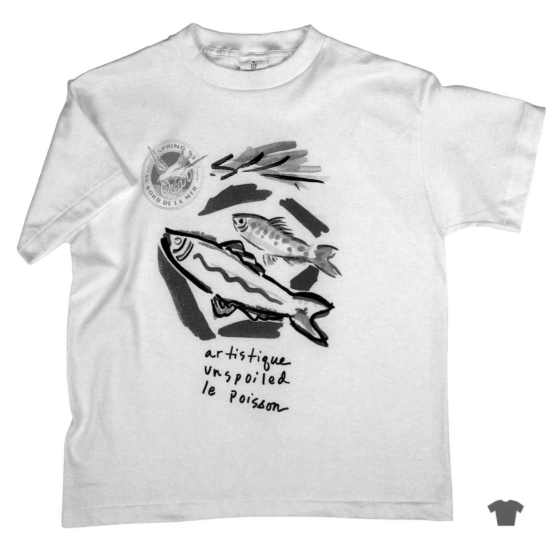

artistique
unspoiled
le Poisson

The Gap

ART DIRECTOR:

Carole Bolger

DESIGNER/ILLUSTRATOR:

Maxine Boll, Lambertville,

New Jersey

PURPOSE: Retail sale

La Nuit est claire

natural landscape

OCHRES CERULEAN BLUE VIRIDIAN GREEN NAPLES YELLOW

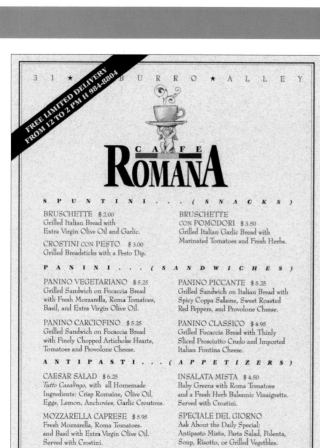

Ann Pagliarulo
Chef / Owner

31 Burro Alley
Santa Fe, New Mexico 87501
(505) 984-8804

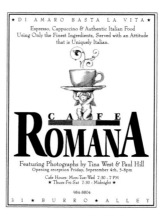

Euro-style café serving espresso coffee, Italian grilled sandwiches and antipasto in a lively atmosphere.

DESIGN FIRM:

Ann Pagliarulo Design, Santa Fe, New Mexico

ART DIRECTOR/

DESIGNER: Ann Pagliarulo

ILLUSTRATOR:

Jane Pagliarulo

BUDGET: $7 each

QUANTITY: 144

PRINTING PROCESS:

Silkscreen, 3-color front, 1-color back

PURPOSE: Retail sale; also part of uniform for employees and delivery person.

Above, left: menu; top: business card, above: newspaper ad. The designer was also chef and owner of the restaurant and did all of her own promotional copywriting.

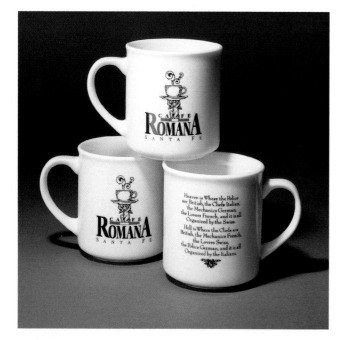

CAFE
ROMANA
SANTA FE

Heaven is Where the Police
are British, the Chefs Italian,
the Mechanics German,
the Lovers French, and it is all
Organized by the Swiss.
Hell is Where the Chefs are
British, the Mechanics French,
the Lovers Swiss,
the Police German, and it is all
Organized by the Italians.

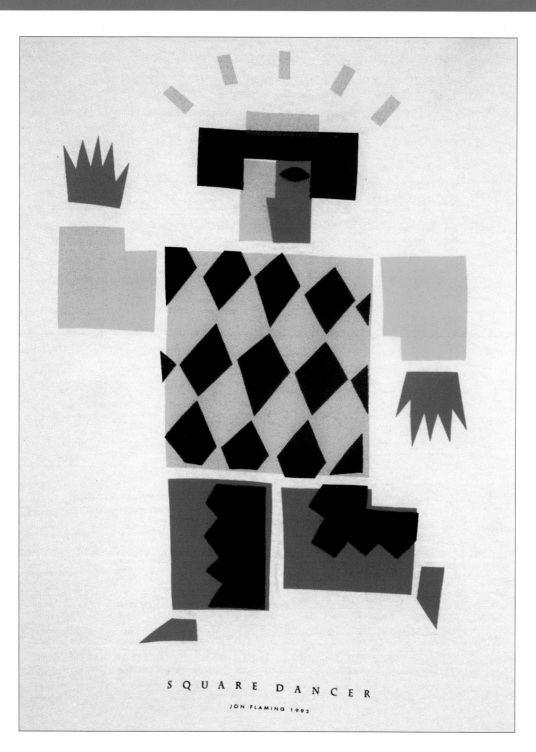

SQUARE DANCER

JON FLAMING 1993

Retail apparel, gifts, cards,

and home accessories.

DESIGN FIRM:

Jon Flaming Design,

Dallas, Texas

ART DIRECTOR/

DESIGNER/ILLUSTRATOR:

Jon Flaming

QUANTITY: 500

PRINTING PROCESS:

Silkscreen

PURPOSE: Retail sale

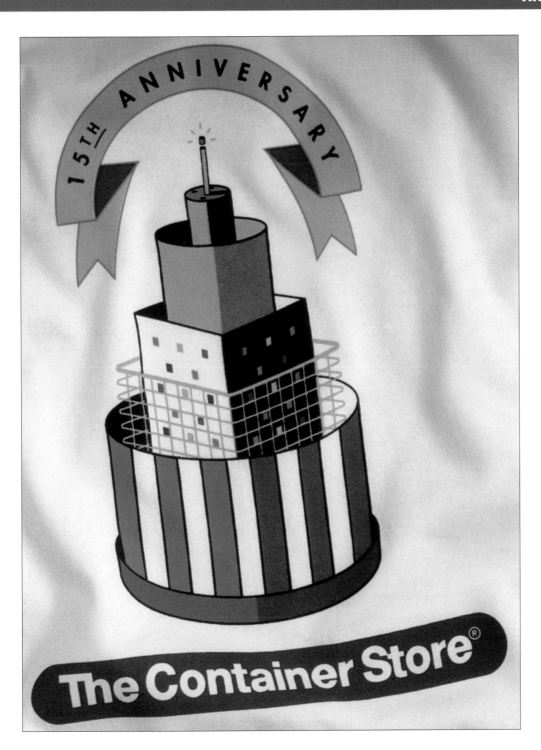

DESIGN FIRM:

Sibley/Peteet Design,

Dallas, Texas

ART DIRECTOR:

Rex Peteet

DESIGNER/ILLUSTRATOR:

Derek Welch

QUANTITY: 250

PRINTING PROCESS:

Silkscreen

PURPOSE: To evoke in

employees a feeling of

celebration during the

store's 15th anniversary.

AGENCY:

Stackig Advertising &

Public Relations,

McLean, Virginia

ART DIRECTOR:

Terry Wilson

DESIGNER/ILLUSTRATOR:

François Fontaine

Ask me about a career in advertising.

COPYWRITER:

Rosser Clark

QUANTITY: 500

PRINTING PROCESS:

1-color silkscreen

PURPOSE: Self-promotion

given to clients, and

vendors, and sold at ad

club meetings.

Women-owned sports marketing and promotion company for off-road cycling events in Northern California.

DESIGN FIRM:

Kahn Artist Design, San Jose, California

ART DIRECTORS:

Linda Kahn, Rose Fallon

DESIGNER/ILLUSTRATOR:

Linda Kahn

SILKSCREENER:

W&T Graphics

BUDGET: $100

QUANTITY: 250

PRINTING PROCESS:

2-color silkscreen

PURPOSE: To promote individual participation in each of the five Lake Tahoe Mountain Bike series events.

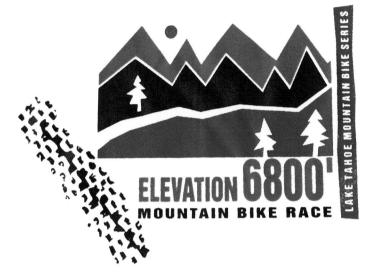

ELEVATION 6800'
MOUNTAIN BIKE RACE

LAKE TAHOE MOUNTAIN BIKE SERIES

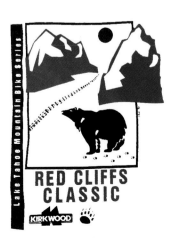

Lake Tahoe Mountain Bike Series

TRAILBLAZE MOUNTAIN BIKE RACE

Lake Tahoe Mountain Bike Series

RED CLIFFS CLASSIC

KIRKWOOD

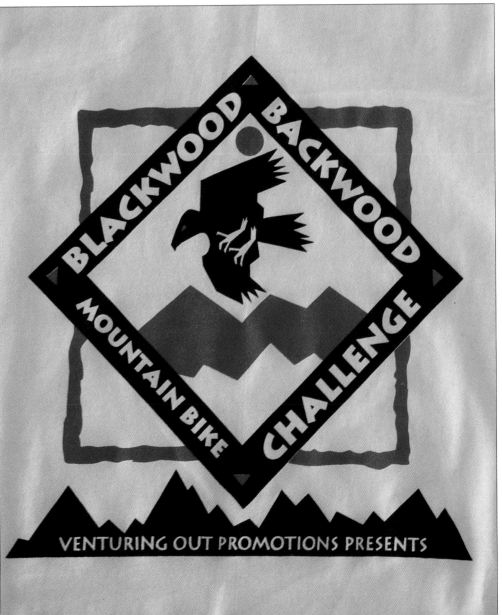

BLACKWOOD BACKWOOD MOUNTAIN BIKE CHALLENGE

VENTURING OUT PROMOTIONS PRESENTS

West Texas Performing Arts Society

AGENCY:

Phil Price Advertising, Inc.,

Lubbock, Texas

ART DIRECTOR/

DESIGNER/ILLUSTRATOR:

Mike Meister

BUDGET: Pro bono

PRINTING PROCESS:

Silkscreen

PURPOSE: General

promotion and premium

for a non-profit

organization that

promotes the area's

performing arts.

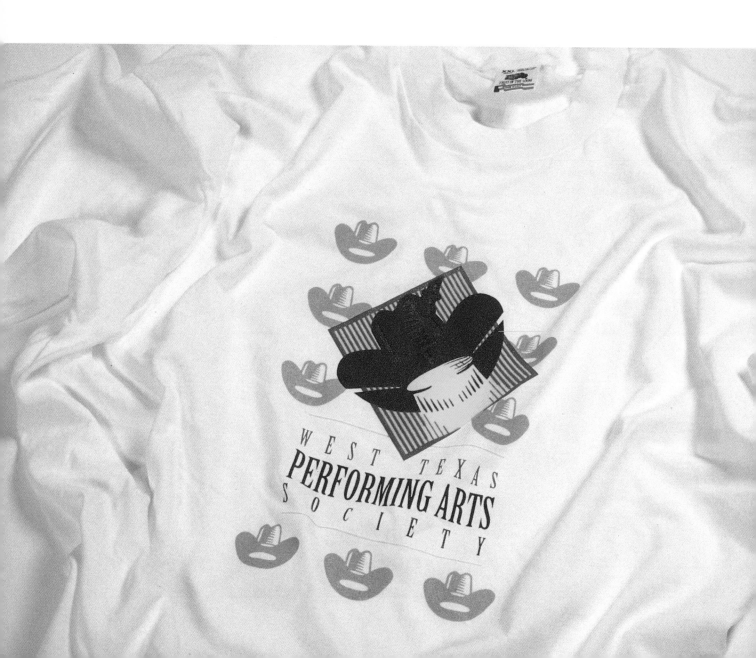

DESIGN FIRM:

Kirby Stephens Design, Inc.,

Somerset, Kentucky

ART DIRECTOR:

Kirby Stephens

DESIGNER/ILLUSTRATOR:

Bill Jones

QUANTITY: 150

PRINTING PROCESS:

3-color silkscreen

PURPOSE: For sale at the event to recoup a portion of the orchestra's fee and as promotion for the following year's event.

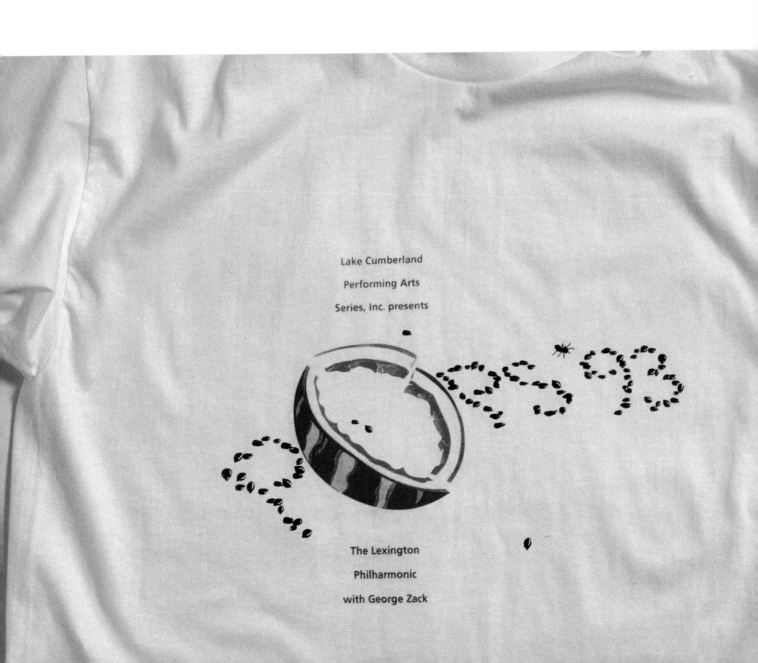

Below: poster; bottom:
commemorative plaques.

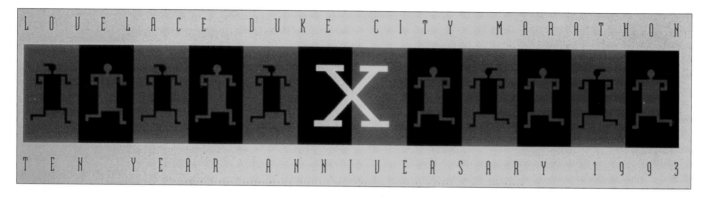

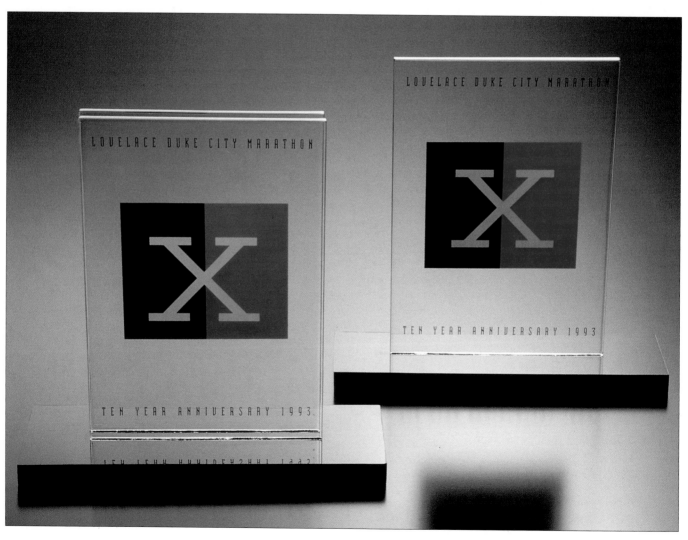

94

DESIGN FIRM:

Vaughn/Wedeen Creative,

Albuquerque, New Mexico

ART DIRECTORS:

Rick Vaughn, Vicki

Newsom

DESIGNER/ILLUSTRATOR:

Rick Vaughn

COMPUTER PRODUCTION:

Chip Wyly

QUANTITY: 6000

PRINTING PROCESS:

Silkscreen

PURPOSE: Marathon

promotion/souvenir.

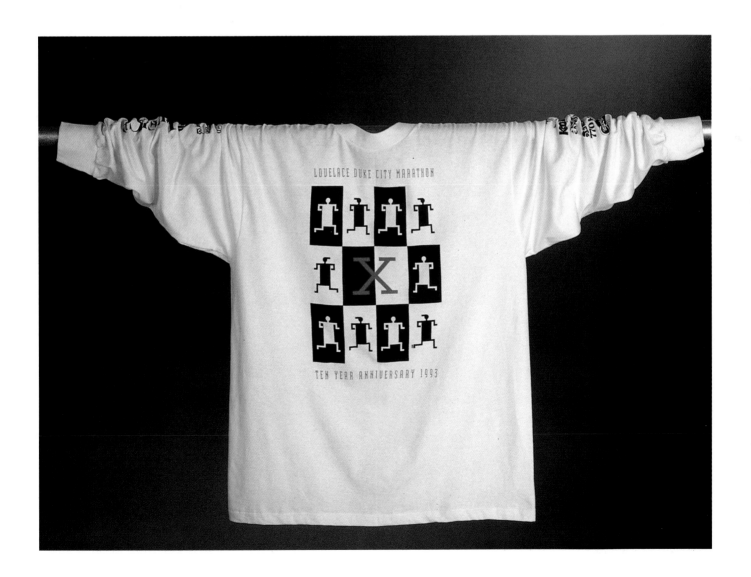

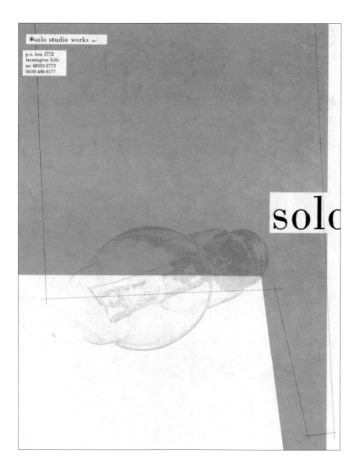
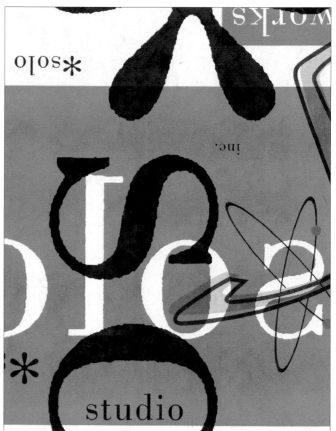

DESIGN FIRM:

Pepellashi+Rae,

Southfield, Michigan

ART DIRECTOR/

DESIGNER: John W. Latin

PHOTOGRAPHER:

Dorothy Roberts

PRINTING PROCESS:

Silkscreen by hand

PURPOSE: Promotional

Top: front and back of business card; middle: front and back of envelope; bottom: front and back of letterhead.

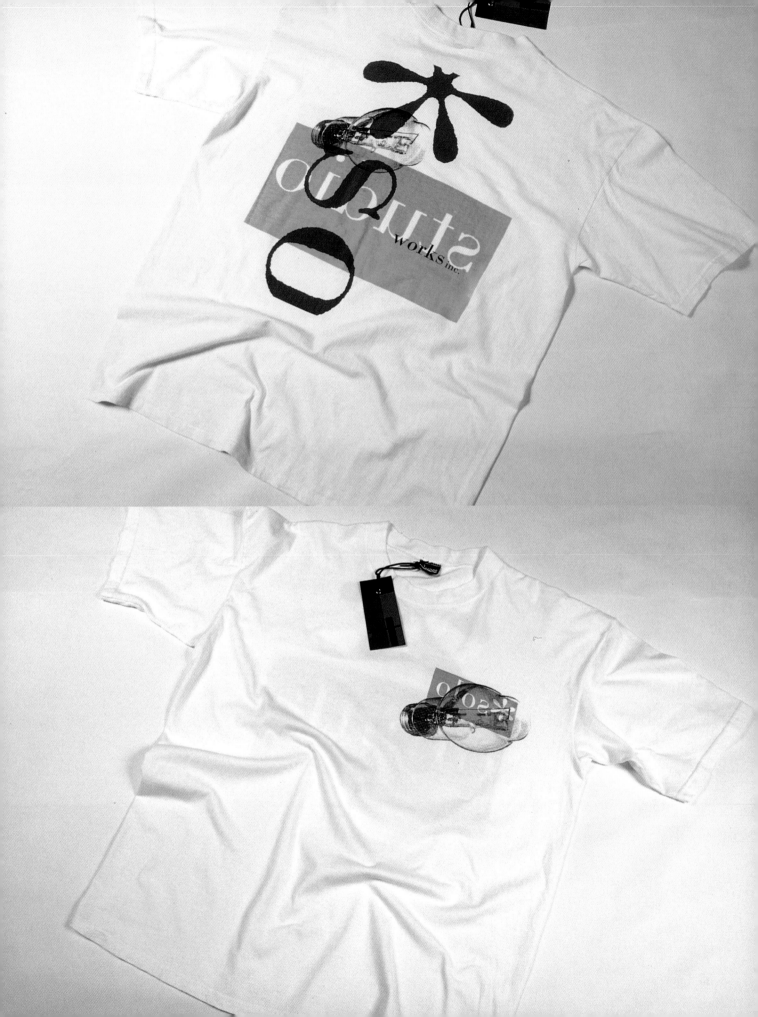

DESIGN FIRM:

Tilka Design, Minneapolis,

Minnesota

ART DIRECTOR: Jane Tilka

DESIGNERS:

Carla Scholz Mueller, Brad

Hartmann

COPYWRITER:

Carla Scholz Mueller

PURPOSE: Retail sale

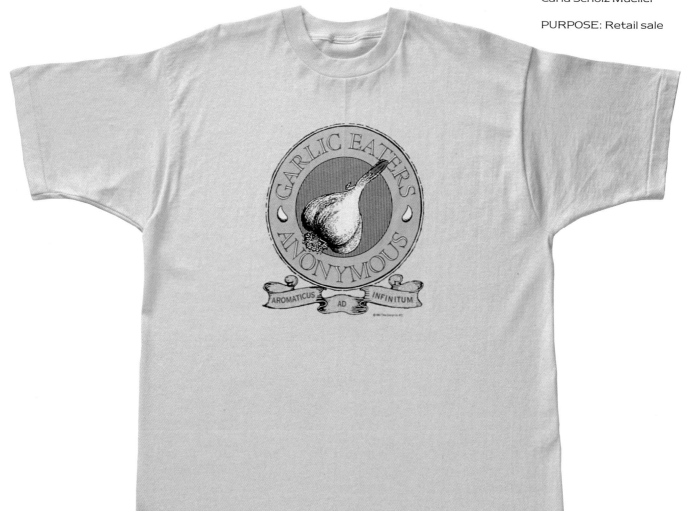

DESIGN FIRM:

Tilka Design, Minneapolis,

Minnesota

ART DIRECTOR: Jane Tilka

DESIGNER/ILLUSTRATOR:

Carla Scholz Mueller

PURPOSE: Holiday

promotional gift

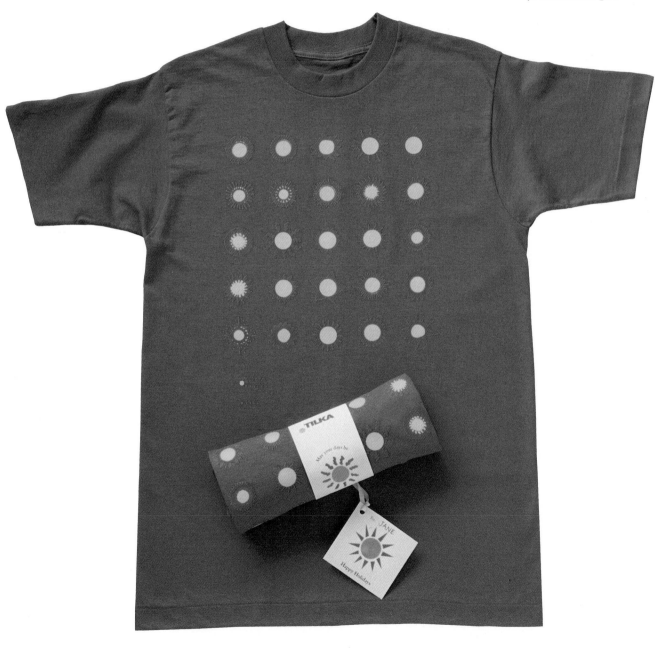

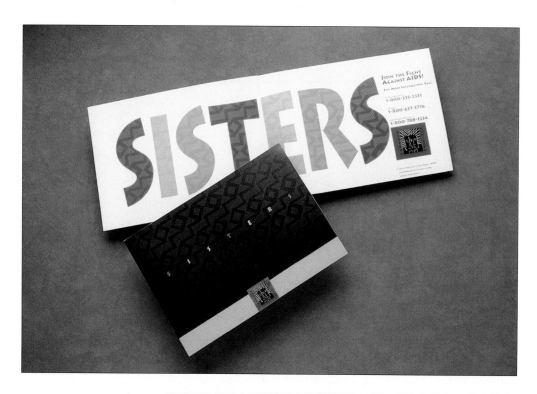

DESIGN FIRM:

Geneva Design Group,

Boston, Massachusetts

ART DIRECTOR:

Marc Sawer

DESIGNERS: Marc Sawer,

Liz DiFranza

QUANTITY: 40,000

PRINTING PROCESS:

Silkscreen

PURPOSE: To promote

AIDS awareness among

teenage women of color.

Massachusetts Department of Public Health

Top: promotional brochure;
bottom: promotional poster.

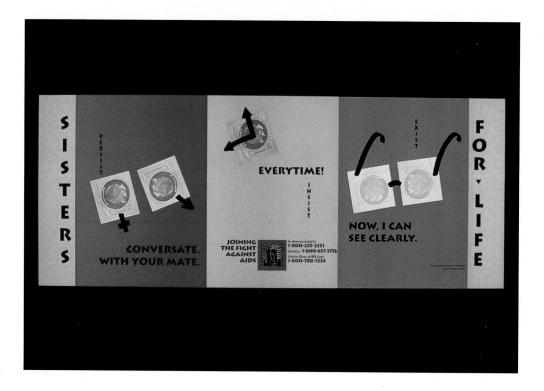

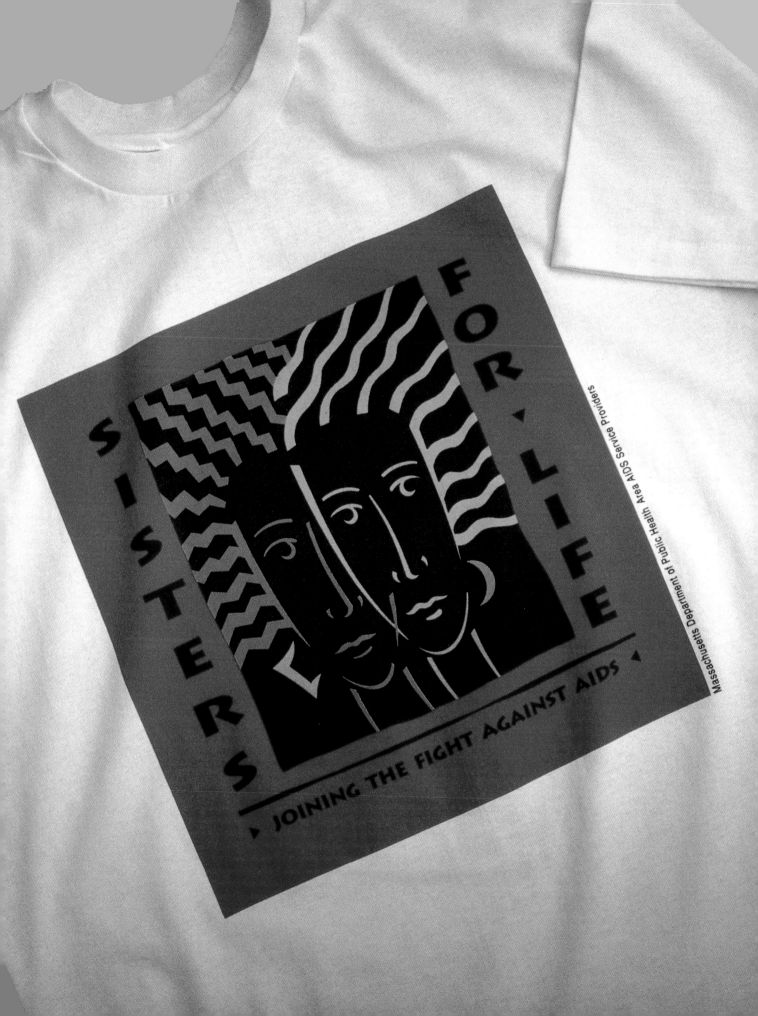

SISTERS FOR·LIFE

JOINING THE FIGHT AGAINST AIDS

Massachusetts Department of Public Health Area AIDS Service Providers

DESIGN FIRM:

Modern Dog, Seattle ,

Washington

ART DIRECTORS:

Laura Penn, Robynne

Raye

DESIGNER:

Robynne Raye

PURPOSE: Staff uniform

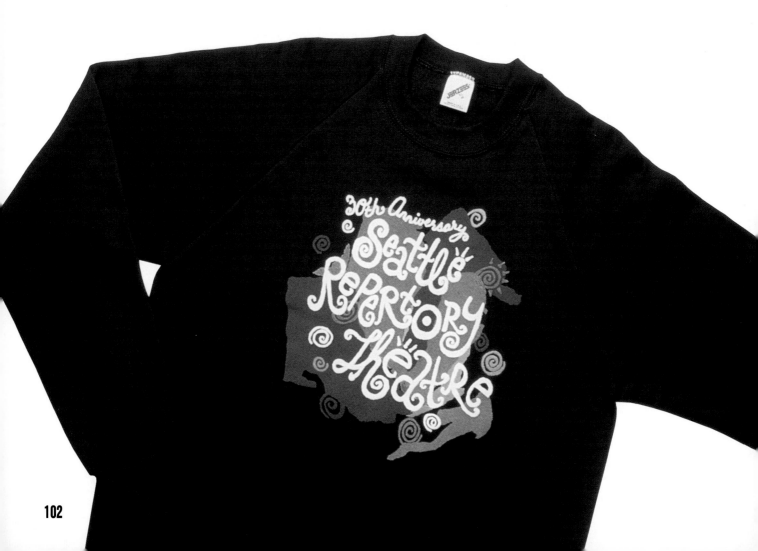

TV commercial post-production (offline and online editing).

DESIGN FIRM: GibbsBaronet, Dallas, Texas

ART DIRECTORS: Willie Baronet, Steve Gibbs

DESIGNER/COPYWRITER: Willie Baronet

ILLUSTRATORS: Kathleen Stevens, Willie Baronet

PURPOSE: Promotional

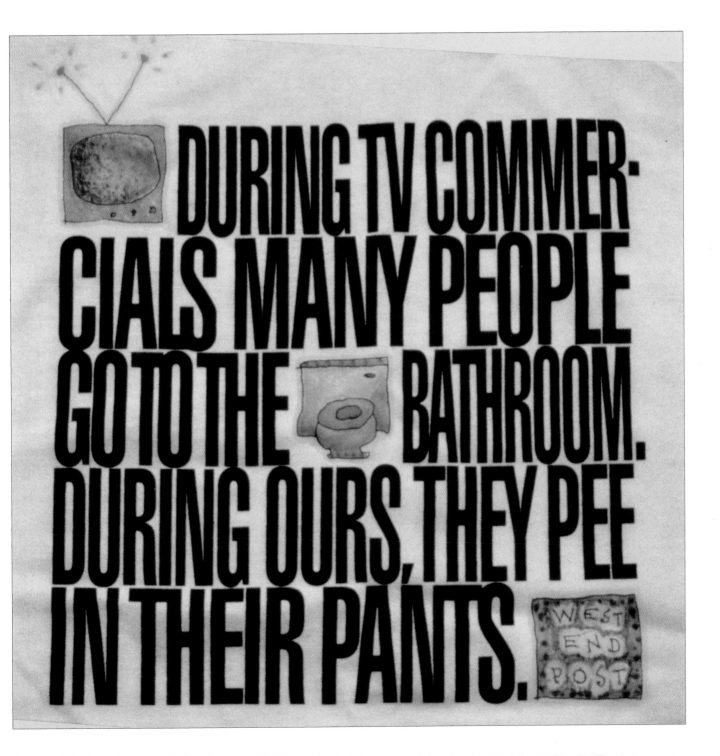

DESIGN FIRM:

Crazy Shirts, Inc., Aiea,

Hawaii

ART DIRECTOR:

Allen Adler

DESIGNER:

Desmond Dano

PURPOSE: Retail sale

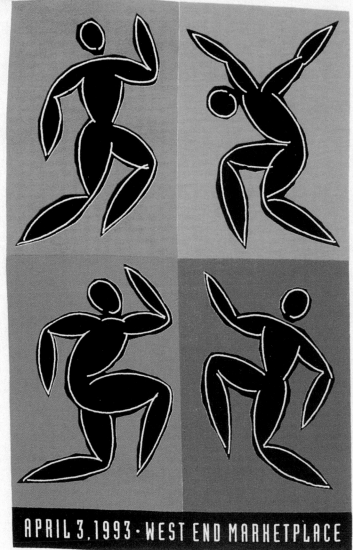

DESIGN FIRM:
Sibley/Peteet Design,
Dallas, Texas

ART DIRECTOR/
DESIGNER/ILLUSTRATOR:
Don Sibley

BUDGET: Pro bono

QUANTITY: 1000

PRINTING PROCESS:
Silkscreen

PURPOSE: To promote an aerobic dance performance benefiting the American Arthritis Foundation.

DESIGN FIRM: Nike, Inc.,

Beaverton, Oregon

ART DIRECTOR:

Angela Snow

DESIGNER/ILLUSTRATOR:

Randy Hamar

PRINTING PROCESS:

Screenprinted, laser

wrap registration

PURPOSE: Part of

Air Jordan Spring 1993

apparel and footwear

offering.

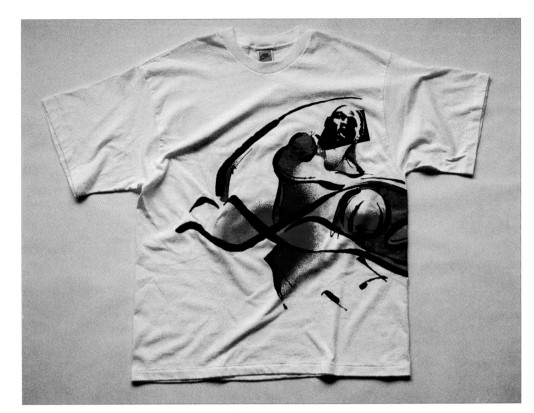

Front.

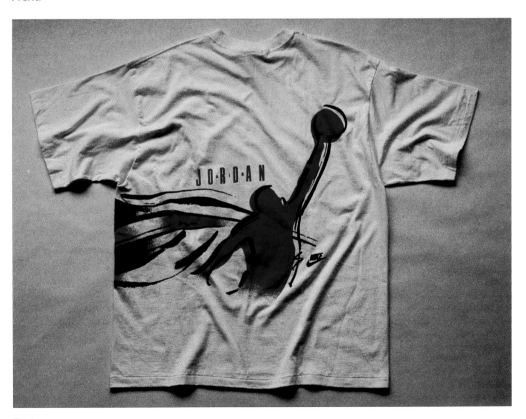

Back.

Nike, Inc. (Sportswear)

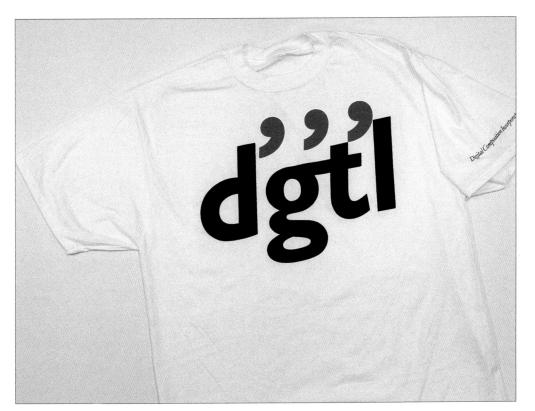

Front.

DESIGN FIRM:

Crosby Associates, Inc.,

Chicago, Illinois

ART DIRECTOR/

DESIGNER: Bart Crosby

BUDGET: $1000

QUANTITY: 200

PRINTING PROCESS:

Silkscreen

PURPOSE: To promote

the company's name and

visual identity.

Back.

Digital Composition Incorporated (Typography & Digital Composition)

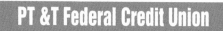
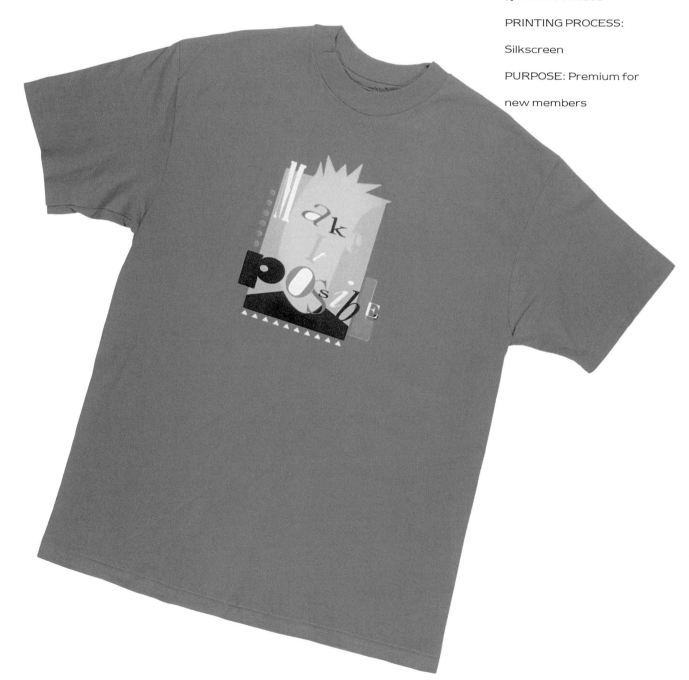

DESIGN FIRM:

The Bradford Lawton

Design Group, San

Antonio, Texas

ART DIRECTOR:

Jennifer Griffith-Garcia

ILLUSTRATOR/DESIGNER:

Bradford Lawton

QUANTITY: 1000

PRINTING PROCESS:

Silkscreen

PURPOSE: Premium for

new members

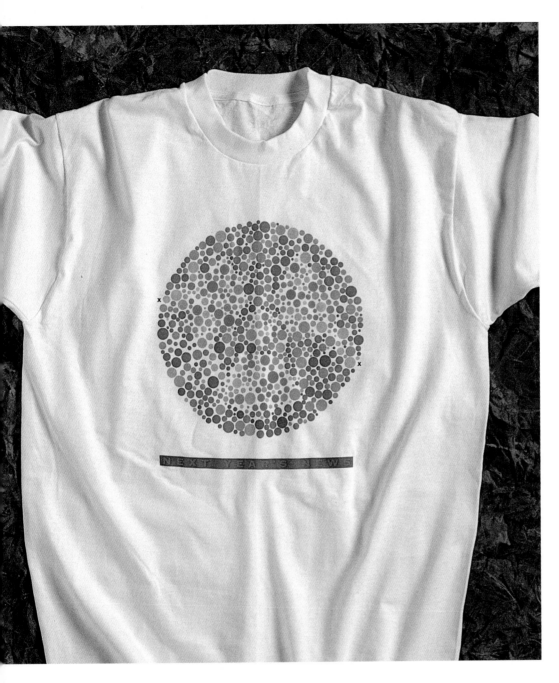

Graphic designers for medical and financial institutions.

DESIGN FIRM:

Next Year's News, Inc., Toledo, Ohio

DESIGNER:

Dwight Ashley

PRINTER:

Erd Specialty Graphics, Inc., Toledo, Ohio

PRINTING PROCESS:

Printed on 100% cotton in 4-color process using an Antec 6-color textile press

PURPOSE: Self-promotion to medically-oriented clientele; uses two familiar elements from medicine—the color perception chart and radiation symbol—to illustrate the theme of pure visual energy.

Next Year's News, Inc.

DESIGN FIRM:

Firehouse 101 Design,

Columbus, Ohio

ART DIRECTOR/

DESIGNER/ILLUSTRATOR:

Kirk Richard Smith

BUDGET: $500

QUANTITY: 100

PRINTING PROCESS:

Hand silkscreened

PURPOSE: Christmas gift

for clients.

Firehouse 101 Design

DESIGN FIRM:

Nike Product Graphics,

Beaverton, Oregon

DESIGNER: Ken Black

ILLUSTRATION:

Warner Bros.

LETTERERS: Ken Black,

Michael Hernandez

QUANTITY: 275,000

PURPOSE: Retail sale

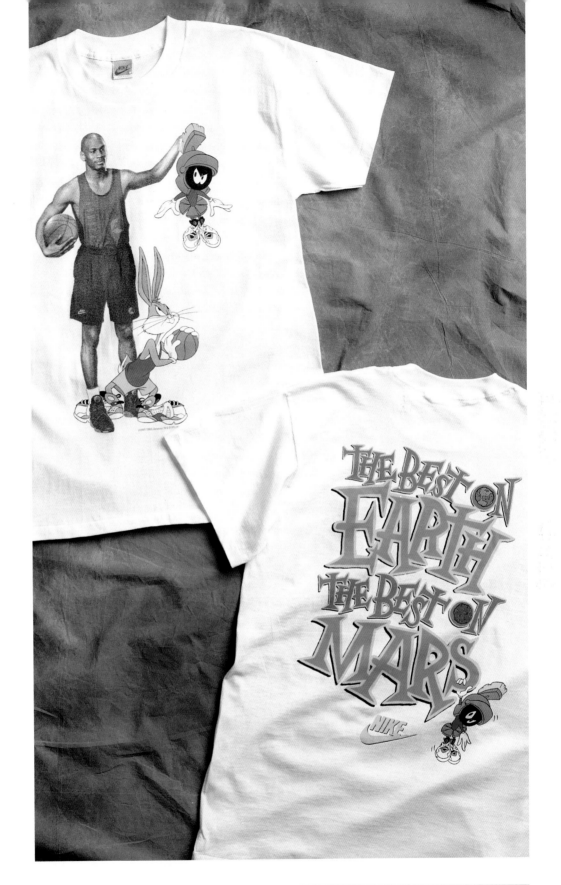

Nike, Inc. (Sportswear)

DESIGN FIRM:

Ideal Design, Crestwood,

Kentucky

ART DIRECTOR/

DESIGNER/ILLUSTRATOR:

Tommie Ratliff

BUDGET: $125

QUANTITY: 10

PRINTING PROCESS:

Silkscreen

PURPOSE: Team shirt

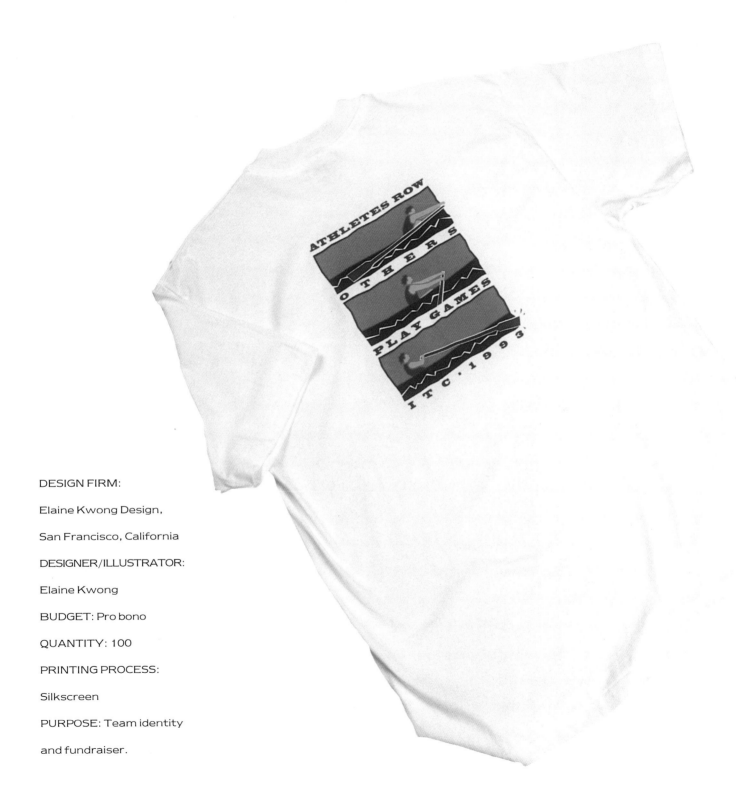

DESIGN FIRM:

Elaine Kwong Design,

San Francisco, California

DESIGNER/ILLUSTRATOR:

Elaine Kwong

BUDGET: Pro bono

QUANTITY: 100

PRINTING PROCESS:

Silkscreen

PURPOSE: Team identity

and fundraiser.

DESIGN FIRM:

Pictogram Studio,

Washington, DC

ART DIRECTOR/

ILLUSTRATOR:

Hien Nguyen

DESIGNERS:

Stephanie Hooton, Hien

Nguyen

BUDGET: $548.26

QUANTITY: 87

PRINTING PROCESS:

Silkscreen

PURPOSE: Holiday T-shirt

sent to clients and friends

as a New Year's greeting.

Right: mailer for T-shirt holiday promotion.

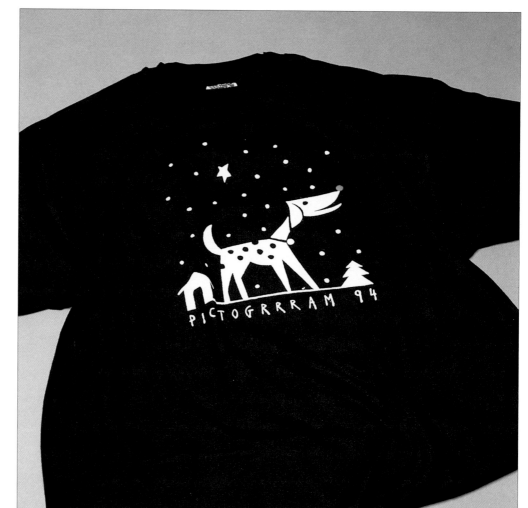

DESIGN FIRM:

Shoebox Greetings,

Kansas City, Missouri

ART DIRECTOR:

Mike Willard

DESIGN DIRECTOR/

ARTIST: Lucy Ware

PURPOSE: Retail sale

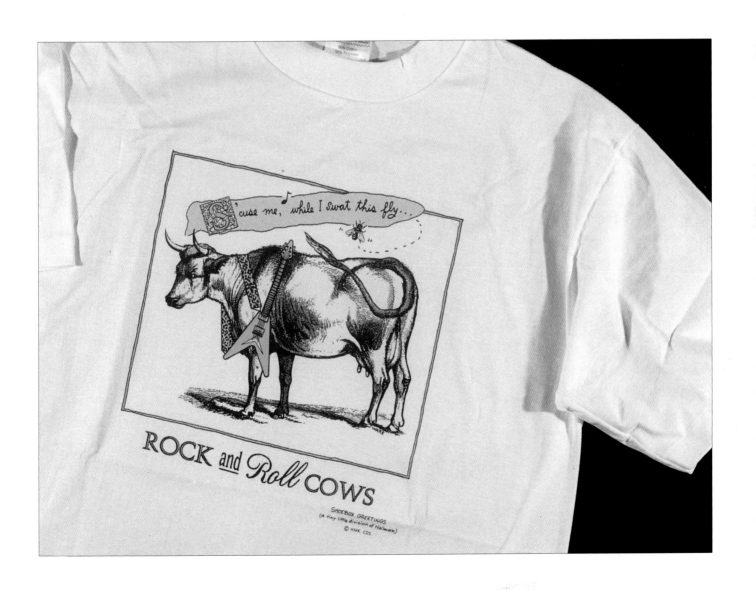

DESIGN FIRM:

The Knape Group,

Dallas, Texas

DESIGNERS: Les Kerr,

James Michael Starr

ILLUSTRATOR:

Dan Birlew

QUANTITY: 250–500

PRINTING PROCESS:

Silkscreen

PURPOSE: To promote an event at the American Institute of Architects monthly meeting designed to demonstrate the sensitivity of architects and office supply manufacturers to the problems of Americans with disabilities. Participants, some of them blindfolded and some of them in wheelchairs, were made to negotiate public spaces.

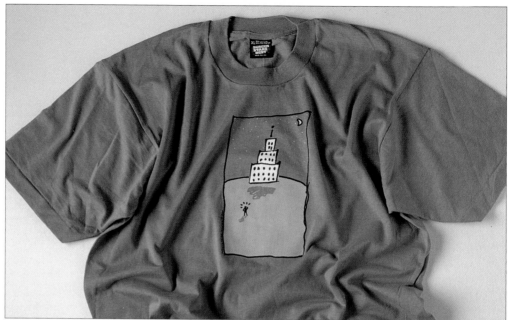

Front.

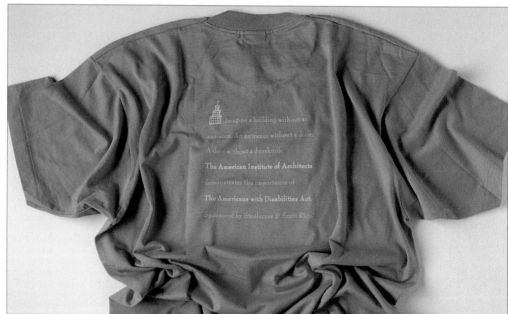

Back.

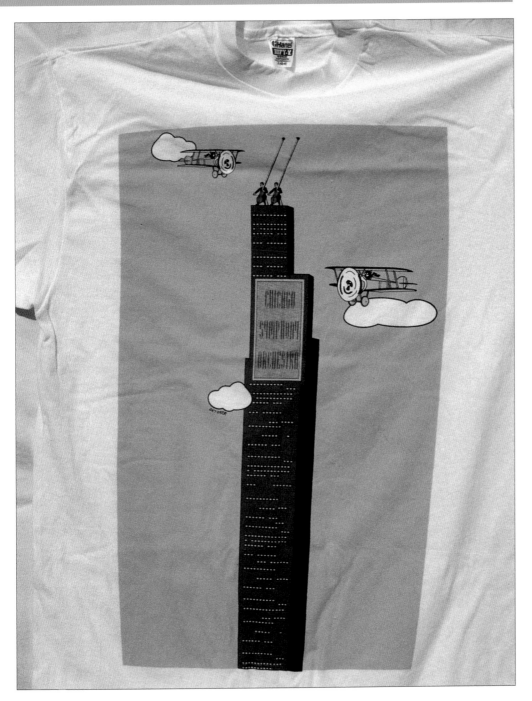

DESIGN FIRM:

Detzner Design,

Chicago, Illinois

ART DIRECTOR/

DESIGNER/ILLUSTRATOR:

Dick Detzner

PURPOSE: Promotional

DESIGN FIRM:

Completely Creative,

Atlanta, Georgia

DESIGNER/ILLUSTRATOR:

Nina Laden

PRINTING PROCESS:

Silkscreen

PURPOSE: Promotional;

the character on the shirt

(and in ads) was based

on a pre-Colombian gold

statue—but "jazzed up."

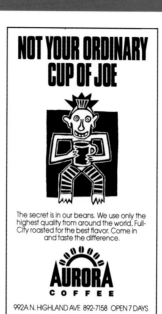

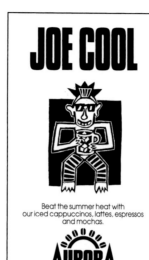

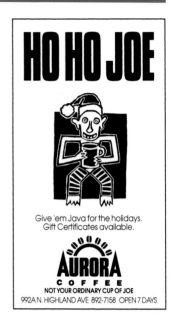

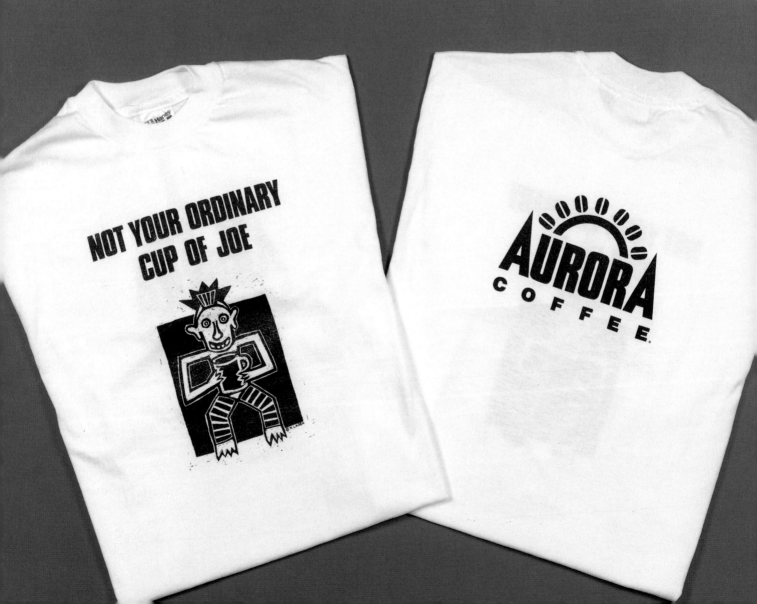

AIGA (1993 Miami Conference)

At the time of the conference, there was a rash of shootings that targeted tourists.

DESIGN FIRM:
Peterson & Company, Dallas, Texas

ART DIRECTOR:
Bryan L. Peterson

DESIGNER: Jan Wilson

BUDGET: $300

QUANTITY: 100

PRINTING PROCESS:
Silkscreen

PURPOSE: Promotional

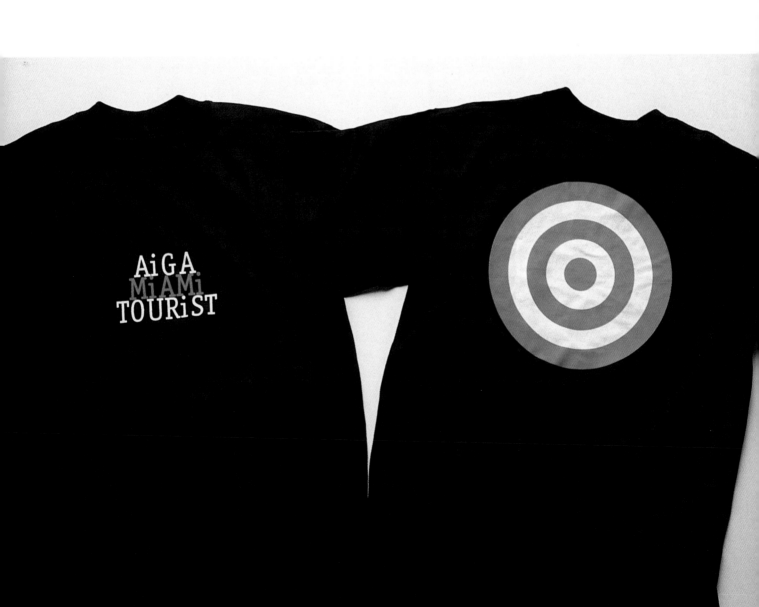

At the time of the

DESIGN FIRM:

Winterland Productions,

San Francisco, California

ART DIRECTOR:

Sandra Horvat Vallely

DESIGNER: Trina Franklin

PURPOSE: Retail sale

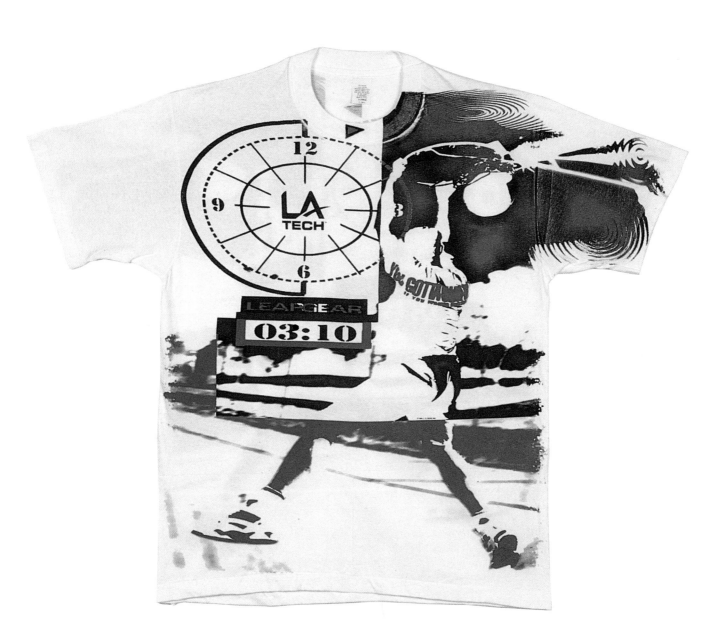

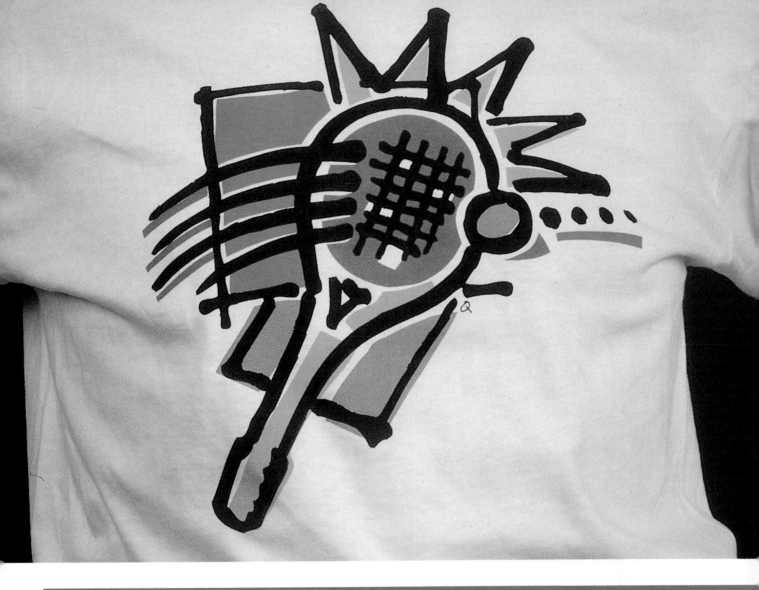

Clairol (Hair & Beauty Products)

DESIGN FIRM:

Mike Quon Design Office,

New York, New York

ART DIRECTOR: S. Fishoff

DESIGNER/ILLUSTRATOR:

Mike Quon

BUDGET: $5000

PRINTING PROCESS:

Silkscreen

PURPOSE: To promote

Clairol tennis tournament.

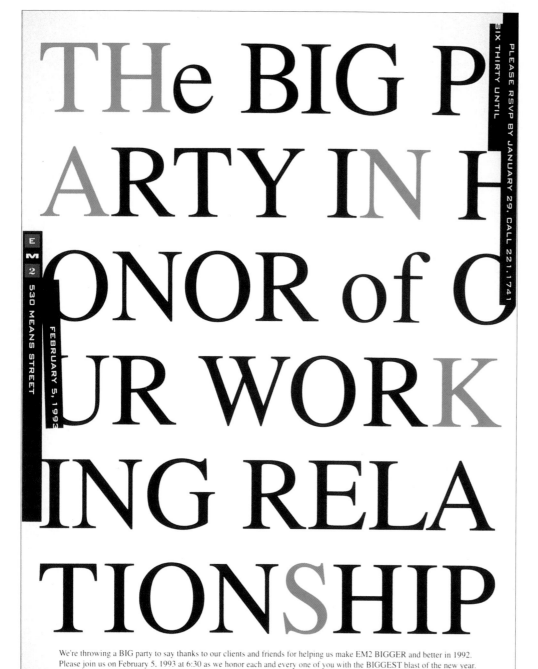

THe BIG PARTY IN HONOR of OUR WORKING RELATIONSHIP

PLEASE RSVP BY JANUARY 29. CALL 221.1741

SIX THIRTY UNTIL

E M 2
530 MEANS STREET

FEBRUARY 5, 1993

We're throwing a BIG party to say thanks to our clients and friends for helping us make EM2 BIGGER and better in 1992. Please join us on February 5, 1993 at 6:30 as we honor each and every one of you with the BIGGEST blast of the new year.

DESIGN FIRM:

EM2 Design,

Atlanta, Georgia

ART DIRECTOR/

DESIGNER:

Maxey Andress

QUANTITY: 15 T-shirts,

250 posters

PRINTING PROCESS:

Silkscreen (T-shirt),

lithography (poster)

PURPOSE: To promote a

thank-you party for

clients.

SALUTE
CHEERS
MERCI
THANKS
BRAVO
PRAISE
GRAC!A

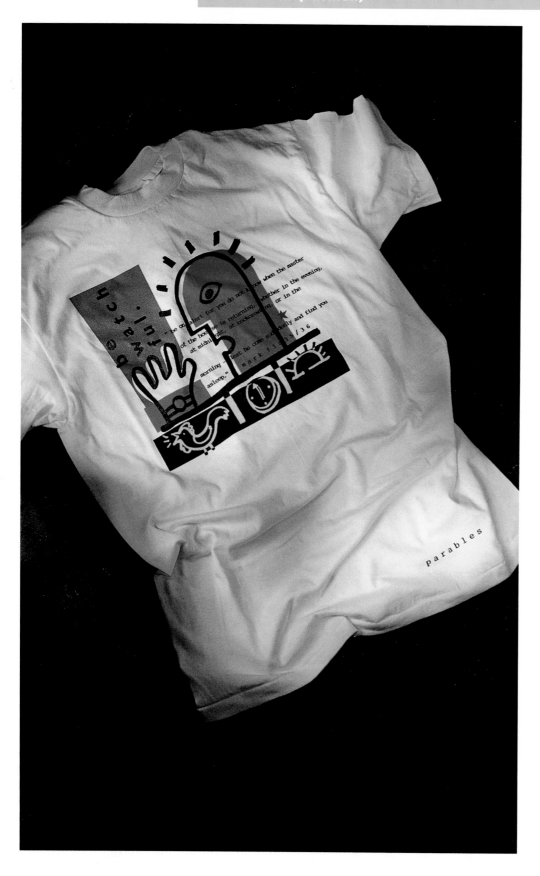

DESIGN FIRM:

BlackBird Creative,

Raleigh, North Carolina

ART DIRECTOR/

DESIGNER/ILLUSTRATOR:

Patrick Short

BUDGET: $559

QUANTITY: 72

PRINTING PROCESS:

Silkscreen

PURPOSE: To deliver a

Christian message in a

fresh and hip manner.

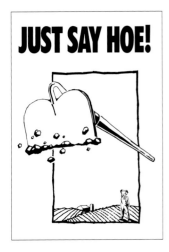

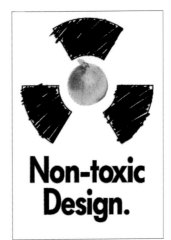

DESIGN FIRM:

Graphik Onion, Columbus,

Ohio

ART DIRECTOR/

DESIGNER/COPYWRITER:

Thomas Slayton

QUANTITY: 144

PRINTING PROCESS:

Silkscreen

PURPOSE: The shirt was

a follow-up to a series of

postcards—a promotional

item that was wearable.

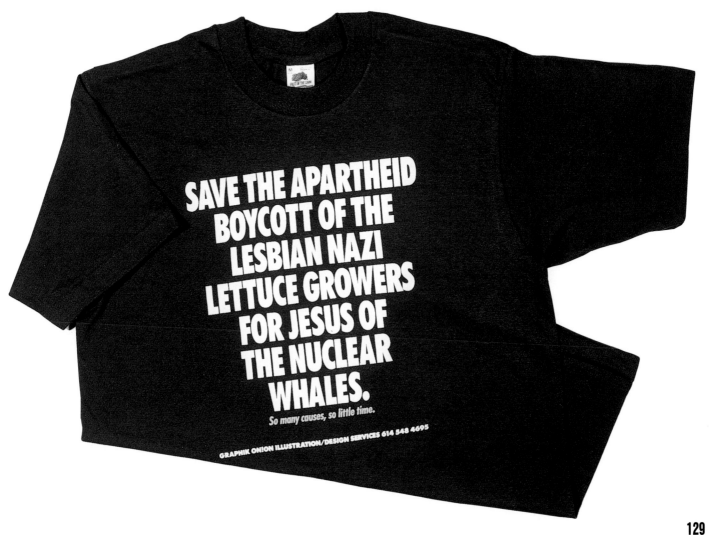

The Bon Marché (Department Store)

DESIGN FIRM:

The Bon Marché,

Seattle, Washington

ART DIRECTOR/

DESIGNER:

Matthew Bertolone-Smith

ILLUSTRATOR:

Judy Pedersen

COPYWRITER:

Don Stephenson

HAND LETTERING:

Bruce Hale

PRINTER:

Bensussen Deutsch,

Kirkland, Washington

BUDGET: $30,000

QUANTITY: 4500

PRINTING PROCESS:

4-color and 1 PMS color

for the type

PURPOSE: Promotion for Mother's Day—mother and child day at Woodland Park Zoo in Seattle sponsored by The Bon Marché.

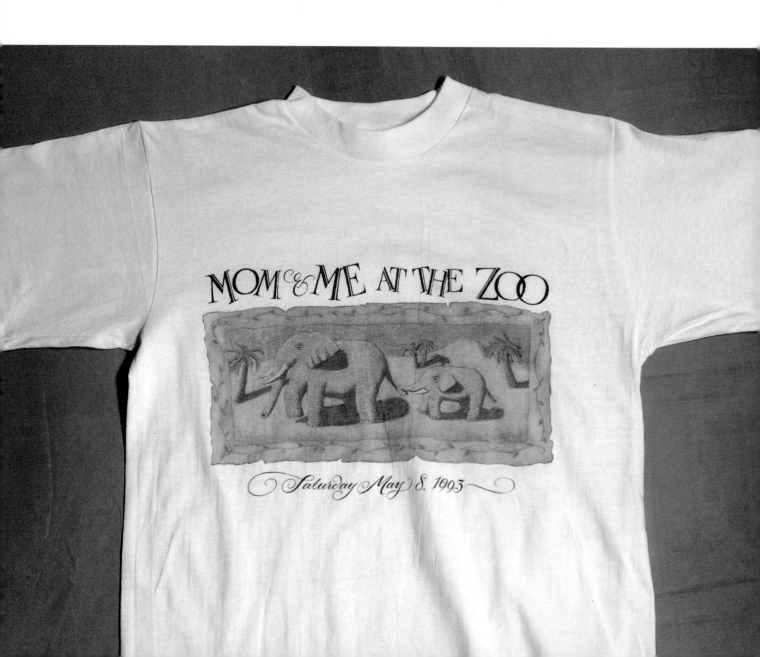

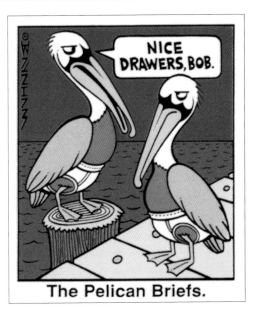

The Pelican Briefs.

DESIGNER/ILLUSTRATOR:

John S. Baynham,

San Diego, California

PRINTING PROCESS:

Silkscreen

PURPOSE: Retail sale

Left: Other designs in a line of humorous T-shirts.

DESIGN FIRM:

David Plunkert Studio,

Baltimore, Maryland

DESIGNER:

David Plunkert

BUDGET: $1400

QUANTITY: 300

PRINTING PROCESS:

Silkscreen

PURPOSE: Retail sale

Zed Wear/George Mimnaugh

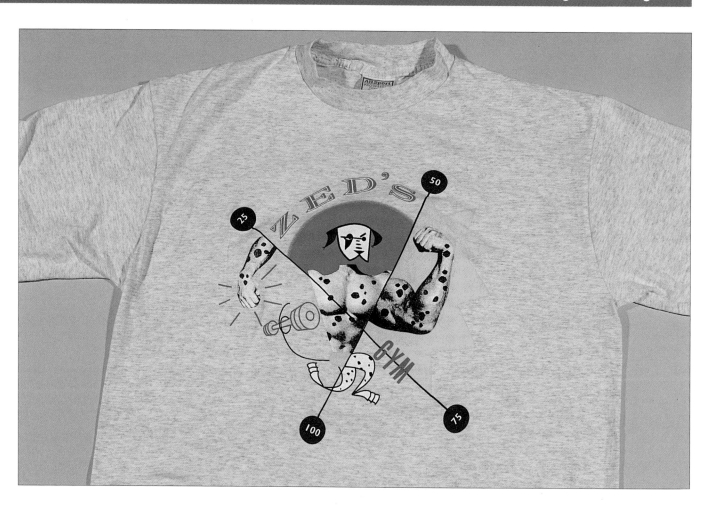

1309 Noble Street Philadelphia Pennsylvania 19123.3620 U.S.A.

DESIGN FIRM:

Paradigm:design,

Philadelphia, Pennsylvania

ART DIRECTOR/

DESIGNER: Joel Katz

BUDGET: $5 per shirt plus

ancilliary materials: label,

card, envelope, box

QUANTITY: 300

PRINTING PROCESS:

Silkscreen

Paradigm:design

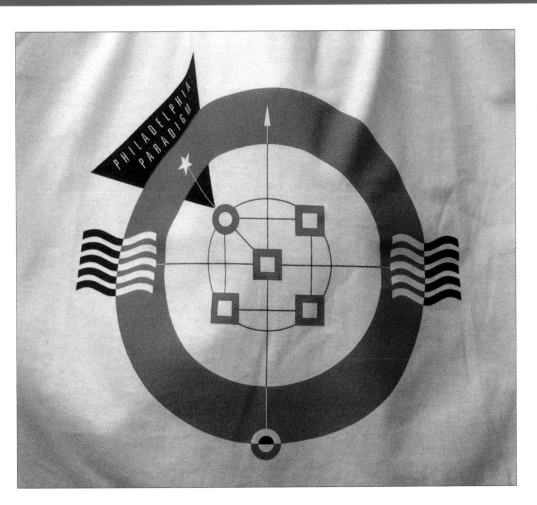

PURPOSE: Holiday gift to clients and friends of the design firm; the result of the merger of Katz Design Group, graphic designers, and Bressler Group, industrial designers. The image is an iconic map of Philadelphia, one in the designer's urban icon series.

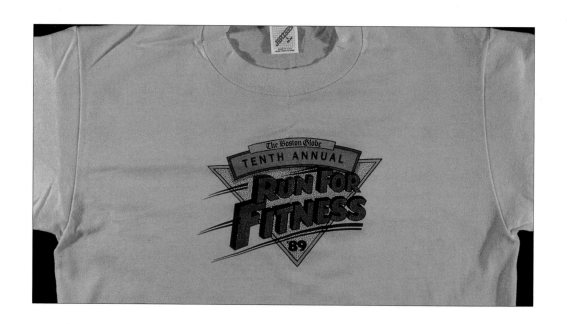

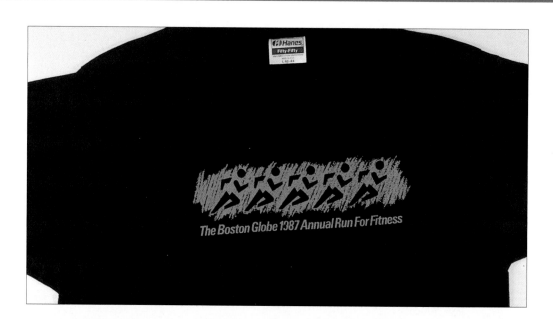

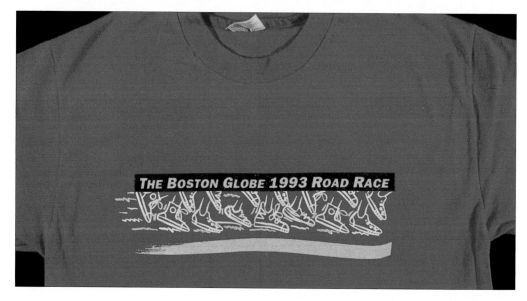

Opposite: shirts from previous years' races.

DESIGN FIRM:
The Boston Globe, Boston, Massachusetts

ART DIRECTORS/ DESIGNERS:
Stephen J. Peña, Jim Gordon (1993)

ILLUSTRATORS:
Stephen J. Peña (1987, 1989), Jim Gordon (1993), John Nelson (1992)

BUDGET: $500 (for art)

QUANTITY: 2000

PRINTING PROCESS:
Silkscreen

PURPOSE: The Globe celebrates Family Day with a road race—2.5 miles. Shirts have been given to participants every year for the past 15 years.

The Boston Globe

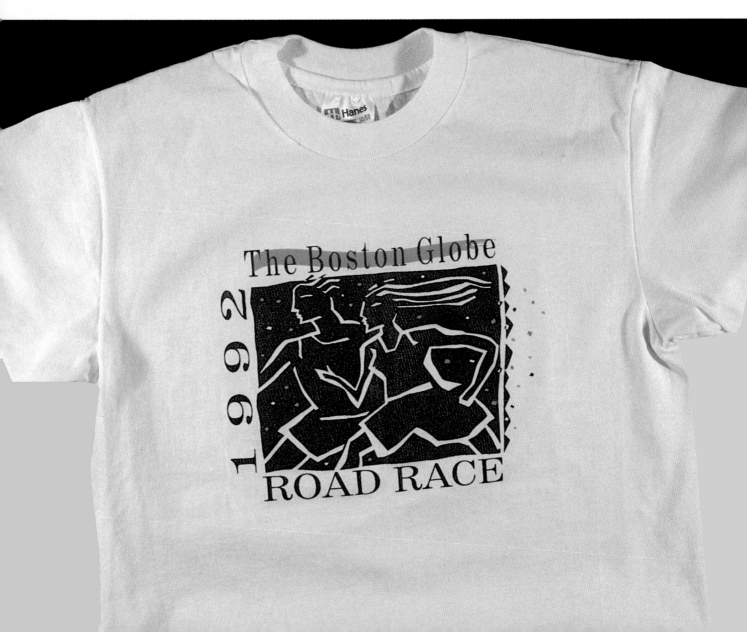

DESIGN FIRM:

Moinx & Co.,

Auburn, Alabama

ART DIRECTOR/

DESIGNER/ILLUSTRATOR:

Chris Bishop

QUANTITY: 12,000

PRINTING PROCESS:

Spot silkscreen

PURPOSE: Retail and

wholesale sales

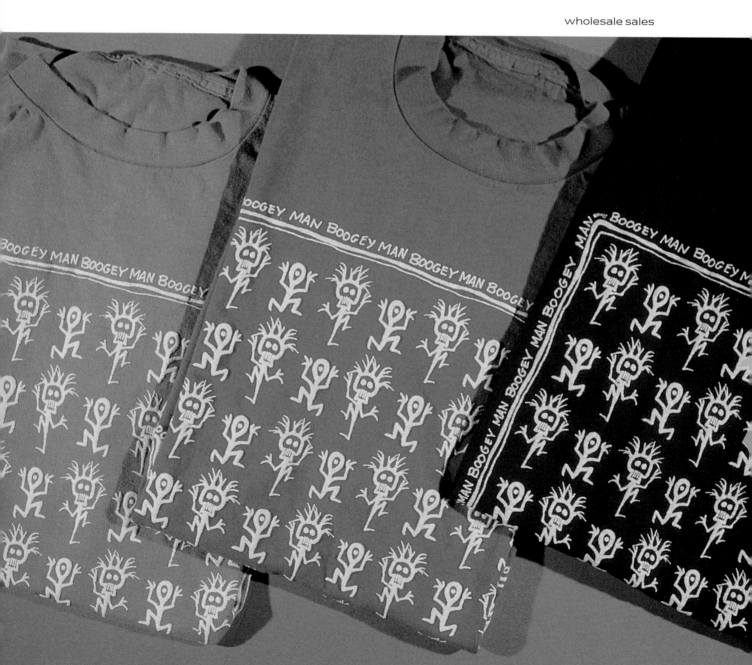

Producers of screenprinted and embroidered sportswear.

DESIGN FIRM:

Van Dusen Illustration, Belfast, Maine

ART DIRECTOR:

Liz Stanley

DESIGNER/ILLUSTRATOR:

Chris Van Dusen

PRINTING PROCESS:

Silkscreen

PURPOSE: Retail sale; these three designs are part of Wild Wares line, promoting public awareness of endangered species. A portion of profits from the sale of these items goes directly to organizations seeking solutions to the planet's problems.

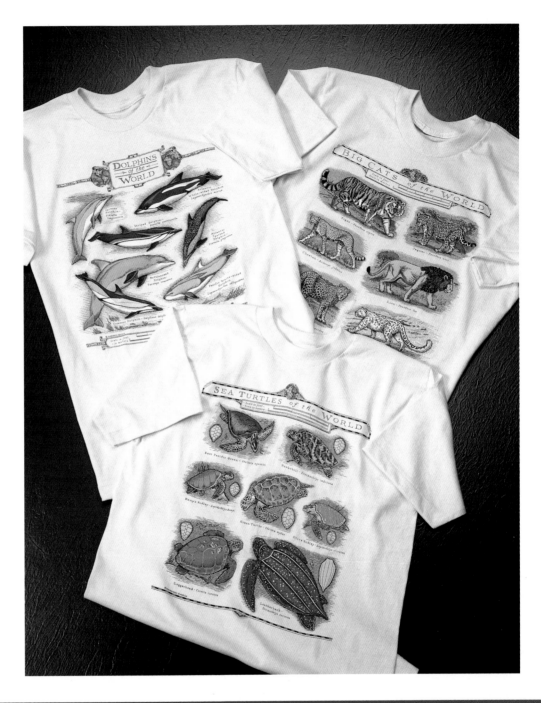

Harborside Graphics Sportswear

DESIGN FIRM:

Garma Graphic Design,

Inc., Waipahu, Hawaii

ART DIRECTOR/

DESIGNER/ILLUSTRATOR:

Alfredo Lista Garma

BUDGET: $6 per shirt

QUANTITY: 1000

PRINTING PROCESS:

Silkscreen

PURPOSE: To promote a

children's fair and to

create familiarity for the

next year's fair.

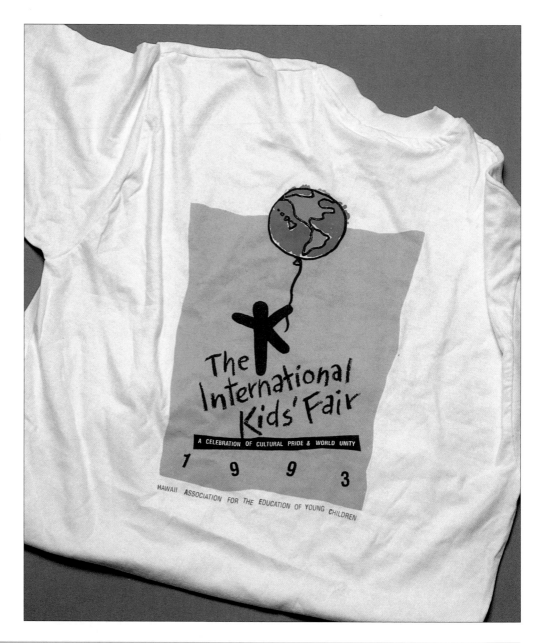

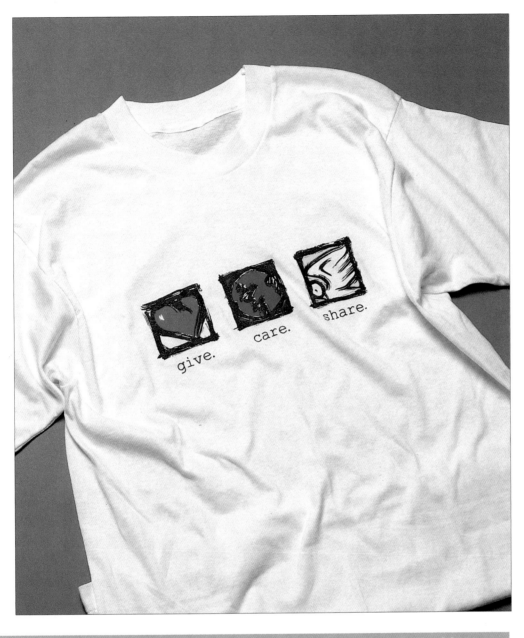

DESIGN FIRM:

Cignal Stores, Joppa,

Maryland

ART DIRECTOR/

ILLUSTRATOR: Karen Ellis

DESIGNERS: Kasha Der,

Karen Ellis

QUANTITY: 3000

PRINTING PROCESS:

Silkscreen

PURPOSE: Retail sale;

Part of program which

raises and donates funds

for three national charities:

AmFAR, Save the Children,

and World Wildlife Fund.

Customers vote on which

of the charities should

receive a donation for that

particular season.

Cignal Stores (Men's and Women's Fashion)

Cignal also retails Christmas cards made of recycled paper to help augment the program. Right: card and envelope.

Brock & the Rockets (A Capella Singing Group)

DESIGN FIRM:
Gnu Design, Ellicott City,
Maryland

ART DIRECTOR/
DESIGNER:
Donald L. Carrick

ILLUSTRATOR: Liz Wolf

BUDGET: $6 per shirt

QUANTITY: 144

PRINTING PROCESS:
2-color silkscreen

PURPOSE: The group
wears the shirts on-stage,
sells them to their fans,

known as the Solid
Rocket Boosters, and
used them as
promotional items for
their album *Out to
Launch*.

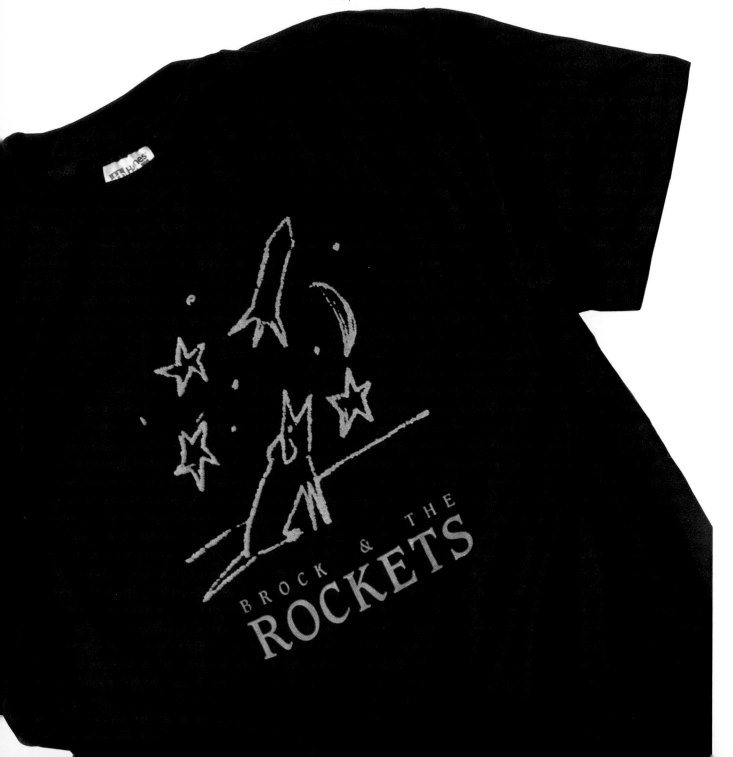

Retail coffee sales and
health-conscious cuisine.
DESIGN FIRM:
Powell Design Office,
Dallas, Texas
ART DIRECTOR/
DESIGNER: Glyn Powell
ILLUSTRATOR: Jon Buell
QUANTITY: 50
PRINTING PROCESS:
Silkscreen
PURPOSE: Retail sale and
servers' uniforms.

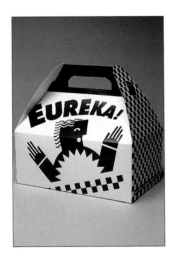

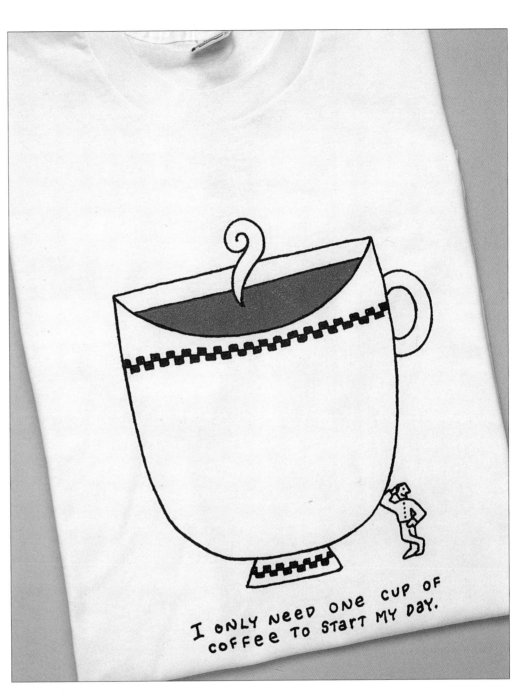

I ONLY NEED ONE CUP OF COFFEE TO START MY DAY.

Eureka!

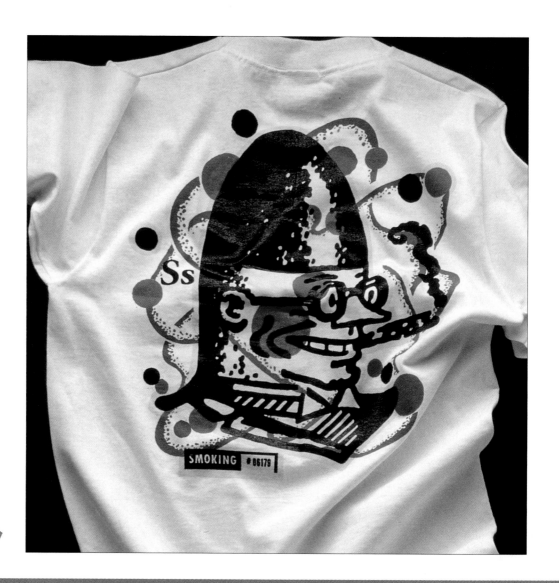

SMOKING # 06179

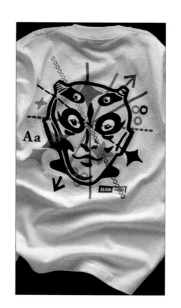

ALIEN

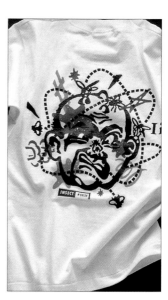

INSECT

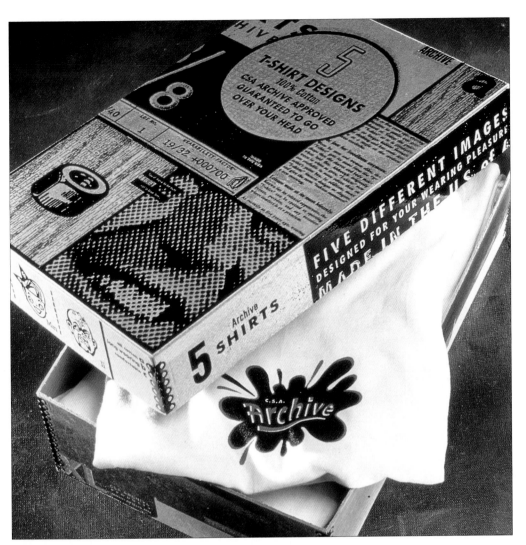

DESIGN FIRM:
Charles S. Anderson
Design Company,
Minneapolis, Minnesota
ART DIRECTOR:
Charles S. Anderson
DESIGNERS:
Charles S. Anderson,
Paul Howalt, Erik Johnson
ILLUSTRATOR:
C.S.A. Archive
PRINTING PROCESS:
Silkscreen glow-in-the-
dark
PURPOSE: To promote
CSA archive.

C.S.A. Archive

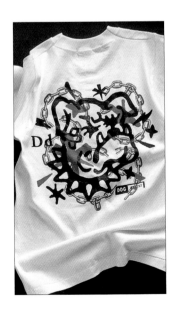
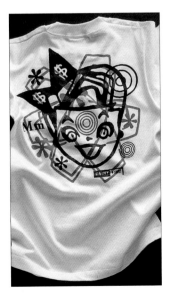
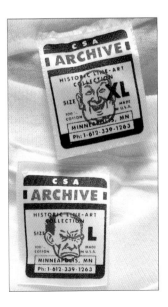

DESIGNER:

Glenn Sweitzer, Franklin,

Tennessee

QUANTITY: 800

PRINTING PROCESS:

5-color silkscreen

PURPOSE: Pledge-drive

promotion and station

promotion.

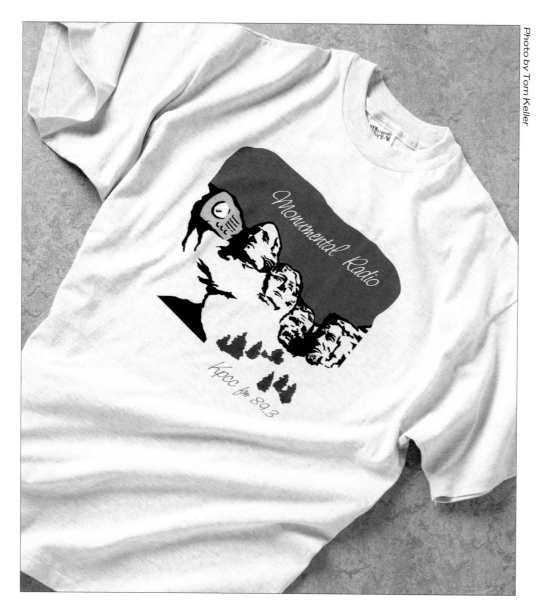

Photo by Tom Keller

DESIGN FIRM:

AT&T/Corporate Design

Studio,Bedminster,

New Jersey

ART DIRECTOR/

DESIGNER/ILLUSTRATOR:

Terry J. Keenan

PURPOSE: To promote an

incentive for AT&T 800

services sales force.

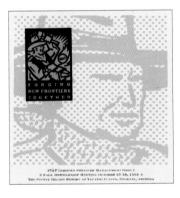

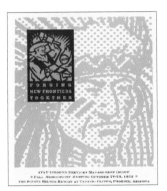

Membership meeting program
(top) and envelope (bottom).

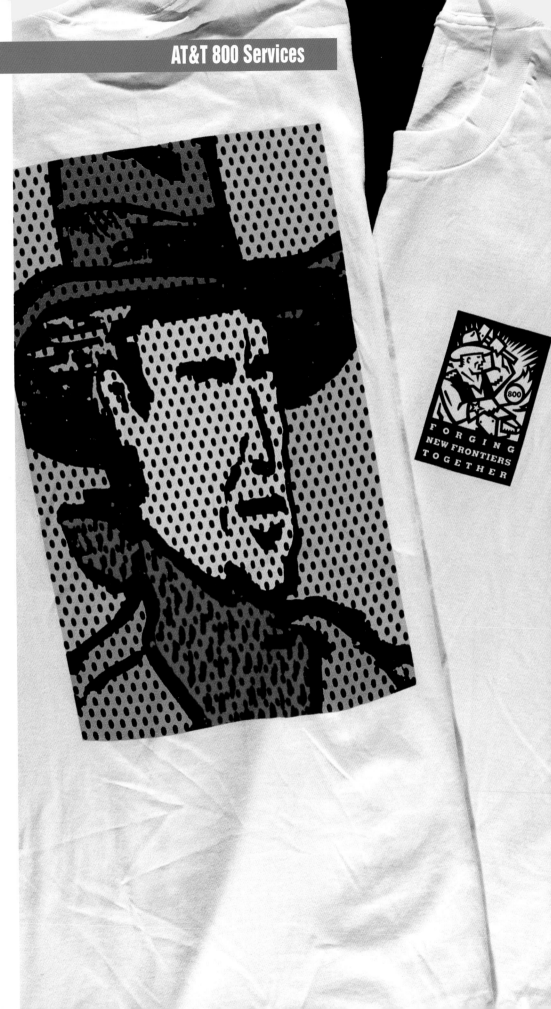

DESIGNER:

Joanne Caroselli,

Scottsdale, Arizona

PRINTER: Hazelwood

Enterprises, Inc.

BUDGET: $5.50 each

QUANTITY: About 2000

PRINTING PROCESS:

Silkscreen: 8 passes—

1 white, 1 puff, 6 colors

PURPOSE: To promote

AMUG at MacWorld

conference in 1992.

Shirts were sold at the

show and to group

members and other

interested individuals.

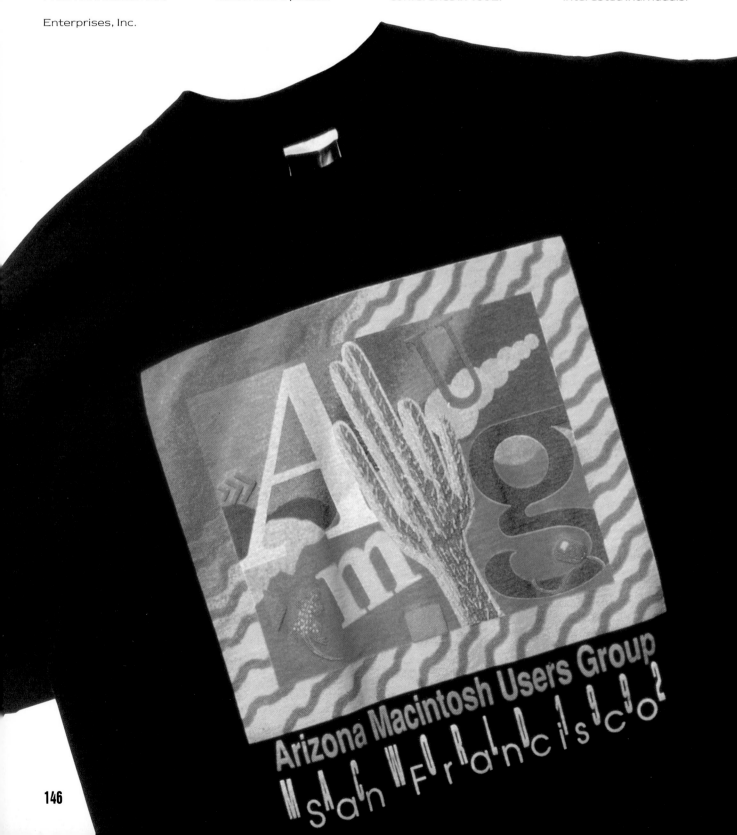

146

DESIGN FIRM:

Deca Design, Inc.,

Gainesville, Florida

DESIGNERS:

Buster O'Connor, Nick

Decarlis

PURPOSE: Promotional

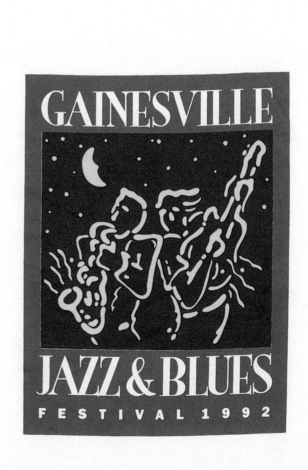

DESIGN FIRM:

Gibson Parsons Design,

Charlottesville, Virginia

DESIGNERS: Jim Gibson,

Mary Parsons

ILLUSTRATORS:

Charles Peale, Jim Gibson

PRINTING PROCESS:

Silkscreen

PURPOSE: Waiters' shirt

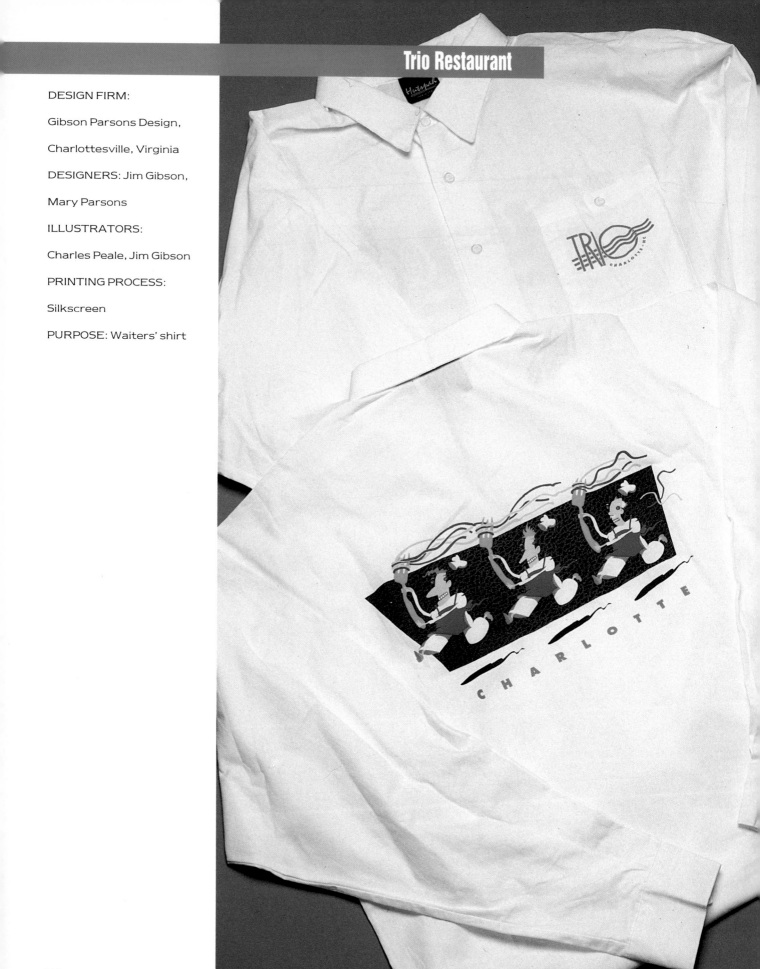

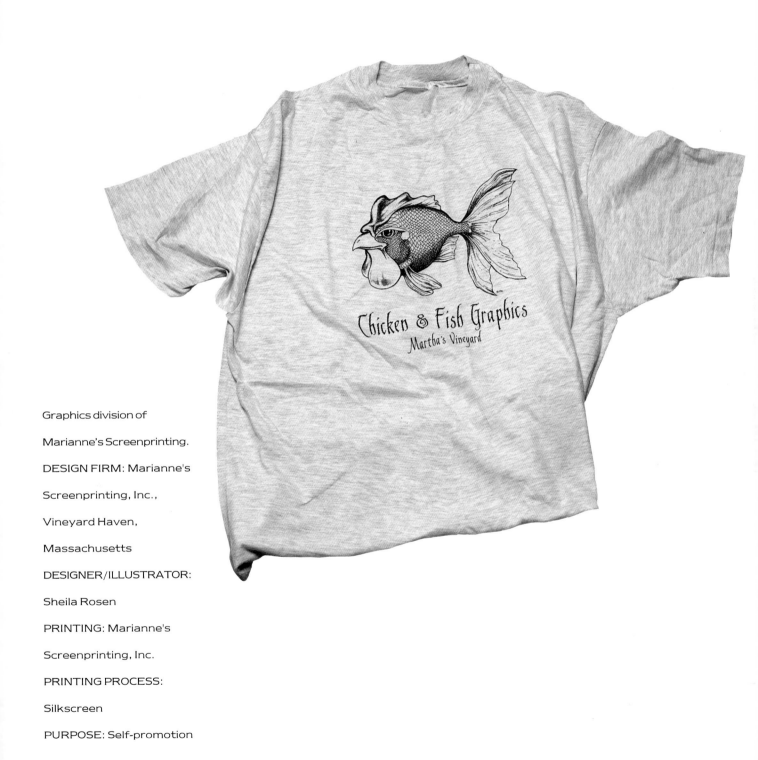

Graphics division of
Marianne's Screenprinting.
DESIGN FIRM: Marianne's
Screenprinting, Inc.,
Vineyard Haven,
Massachusetts
DESIGNER/ILLUSTRATOR:
Sheila Rosen
PRINTING: Marianne's
Screenprinting, Inc.
PRINTING PROCESS:
Silkscreen
PURPOSE: Self-promotion

Chicken and Fish Graphics